On of a b l e

otable Acelebration

© 2000	by	Running	Press
--------	----	---------	-------

All rights reserved under the Pan-American and International Copyright Conventions

Printed in China

This book may not be reproduced in whole or in part, in any form or by any means, electronic or mechanical,including photocopying, recording, or by any information storage and retrieval system now known or hereafter invented, without written permission from the publisher.

9 8 7 6 5 4 3 2 1

Digit on the right indicates the number of this printing.

ISBN 0-7624-0876-6

Cataloging-in-Publication Number 00-131792

Designed by Corinda Cook

Edited by Molly Jay

Photos researched by Susan Oyama and Corinda Cook

Published by Courage Books, an imprint of

Running Press Book Publishers

125 South Twenty-second Street

Philadelphia, Pennsylvania 19103-4399

toy • Maturing • breams and spirituality • Being a Woman • Ambition and Challenge • Love and Coontoon to Maturing • breams and

Being a Woman • Ambition and Challenge • Love and Relations • Creativity •

spirituality Being a Woman Ambition and Challenge Love and Being a Woman Creams and Spirituality Being a Vocation and Spirituality Being and Spirituality Being a Vocation and Spirituality Being and Spirituali	
Ambition and Challenge • Love and Relations • Creativity • Joy • Madams a Ambition and Challenge • Love and Relations • Creativity • Joy • Madams a Ambition and Challenge • Love and Relations • Creativity • Joy • Madams a Ambition and Challenge • Love and Relations • Creativity • Joy • Madams a Ambition and Challenge • Love and Relations • Creativity • Joy • Madams a Ambition and Challenge • Love and Relations • Creativity • Joy • Madams a Ambition and Challenge • Love and Relations • Creativity • Joy • Madams a Ambition and Challenge • Love and Relations • Creativity • Joy • Madams a Ambition and Challenge • Love and Relations • Creativity • Joy • Madams a Ambition and Challenge • Love and Relations • Creativity • Joy • Madams a Ambition and Challenge • Love and Challenge • Love and Relations • Creativity • Joy • Madams a Ambition and Challenge • Love and C	
Relation • Creativity • Joy • Maturing • Dreams and Spirituality • woman Love and Relations • Love and Relations • Creativ 43 Maturing • Dreams and Spirituality • Being a Woman • Ambition and C	3 ∗ Joy •
* Love and Relacificativity Joy * Maturing * Dream 61 and Spir Being a Woman * Ambition and Challenge * Love and Relations * Cresion * Maturing * Dreams and Spirituality * Being a Woman * Ambition Joy	
Challenge • Love and Relations • Creativity • Joy • Maturing • Dreading • Being a Woman • Ambition and Challenge • Love and Foundation • Creativity • Joy • Maturing • Dreams and Spirituality • Being a Maturing • Dreams and Spirituality • Dreams and Spirituali	
Ambition and Challenge • Love and Relations • Creativity • Joy • Maturing • Dreams and Spirituality and Relations • Creativity • Joy • Maturing • Dreams and Spirituality	3 · Love
and Relations • Creativity • 30) • Marting • Dreams and Symmetry	

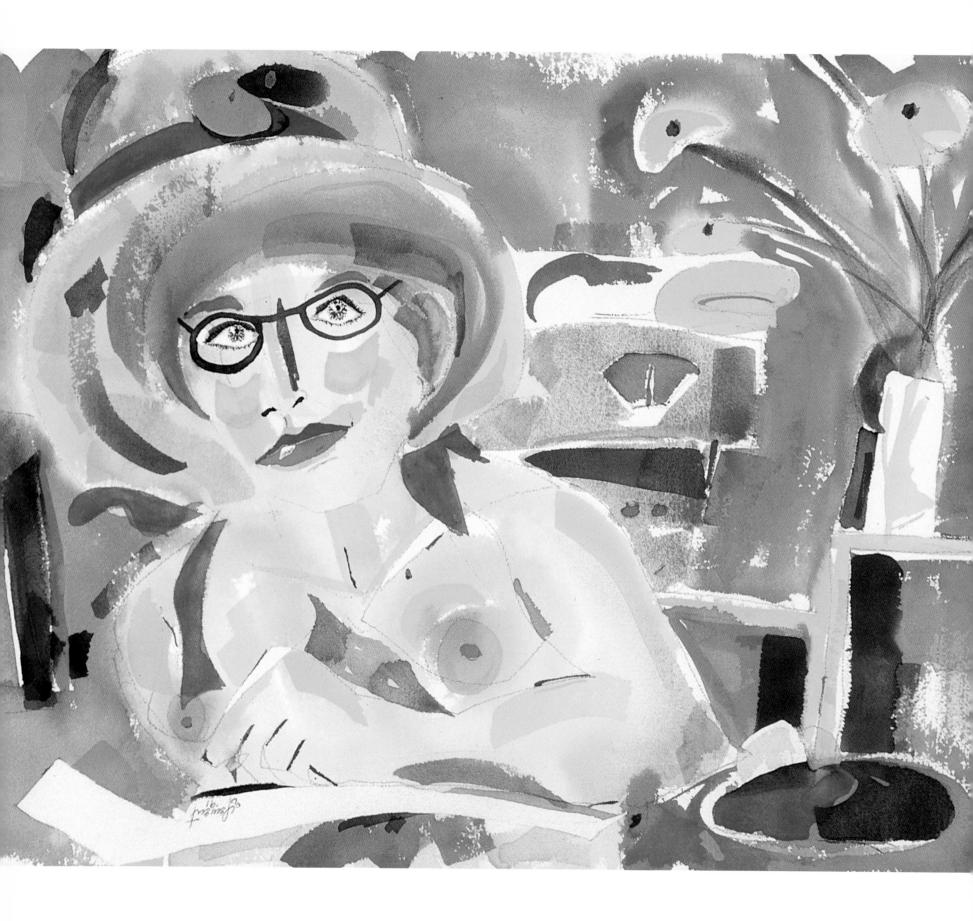

Introduction

They have been at some time in the limelight, have had flair and acuity, a nimble tongue, been able to pinpoint a prodigious notion in a few words, and they've done it with exuberance and certitude. The book you hold is a distillation of thought and reflection from some of the most distinguished female minds, past and present. At once witty, poignant, insightful and touching, the women gathered here speak freely on passion, self-esteem, endurance, secrets, and every other aspect of the human condition that connects us as kindred spirits. Rich illustration by noted female artists compliment each page of wisdom. Each intuition illuminates the next, and these diverse meetings of the mind affirm the universal quality of our experiences.

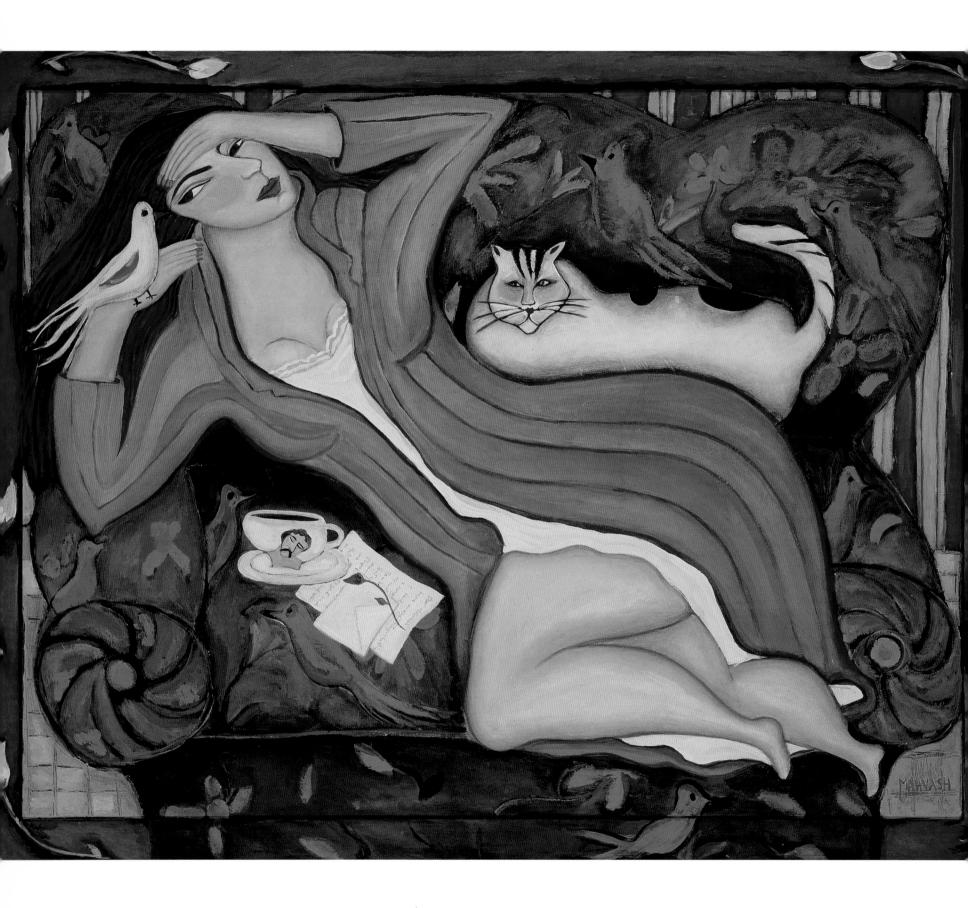

Being a Woman · Ambition and Challenge · Love and Relations · Creativity · loy • Maturing • Dreams and Spirituality • Being a Woman • Ambition and Spirituality • Being a Woman • Ambition and Challenge • Love and Relations, and Spirituality . Being a Woman . and challenge Lave and Stations • Creativity • Joy • Maturing • Creatile Oreams and Spirituality •Being a Woman • Ambition and Challenge • Love and thition and Civilence of Lore and Belgion . Breativity . Joy . Maturing • Dreams and Spirituality • Being a Woman • Ambition and Challenge Love and Relations • Creativity • Joy • Maturing • Dreams and Spirituality • Being a Woman · Ambition and Challenge · Love and Relations · Creativity •; Joy • Maturing • Dreams and Spirituality • Being a Woman • Ambition and Spirituality • Being a Woman • Ambition and Challenge • Love and Relations i Creativity • Joy • Maturing • Dreams and Spirituality • Being a Woman • Ambition and Challenge • Love and Relations • Creativity • Joy • Maturing • Dreams and Spirituality • Being a Woman • Ambition and Challenge • Love and Relations • Creativity • Joy • Maturing • Dreams and Spirituality • Being a Woman · Ambition and Challenge · Love and Relations · Creativity · Joy_•

When she Stopped conforming to the

conventional picture of femininity

she finally began to enjoy being a woman.

Betty Friedman

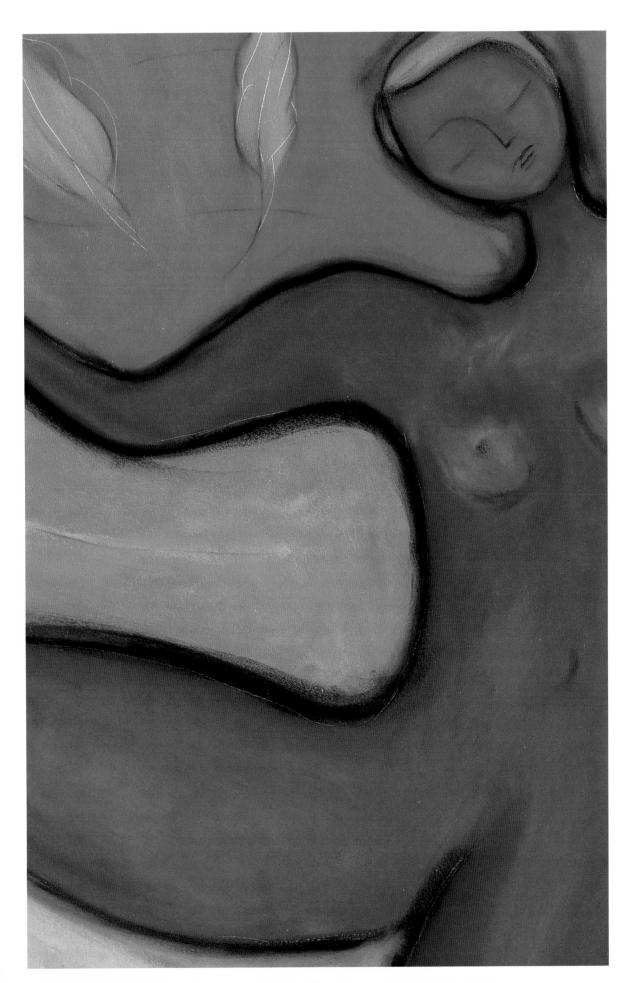

is something
unexplored
about a woman
that only a
woman can
explore...

Georgia O'Keefe

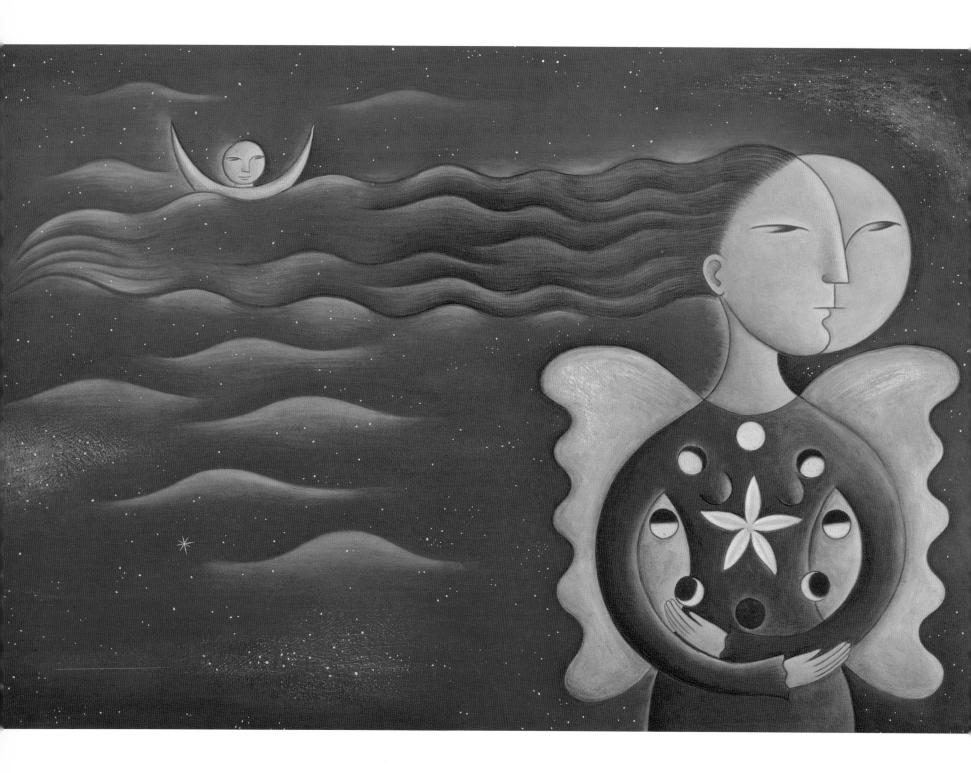

A woman is the full circle. Within her is the power to Create, nurture, and transform. a woman knows that nothing can come to fruition without light. Let us call upon Woman's voice and woman's heart to guide us in this age of planetary transformation.

Diane Mariechild

All human life on the planet is born of woman.

Adrienne Rich

e're all in this together—by ourselves.

Lily Tomlin

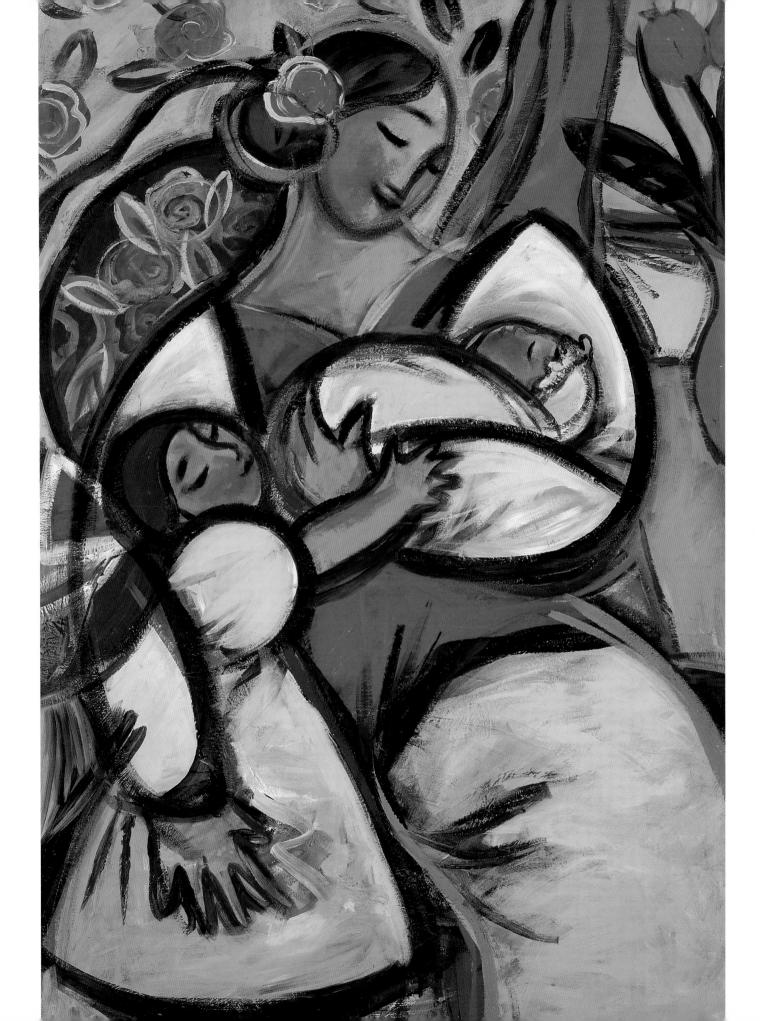

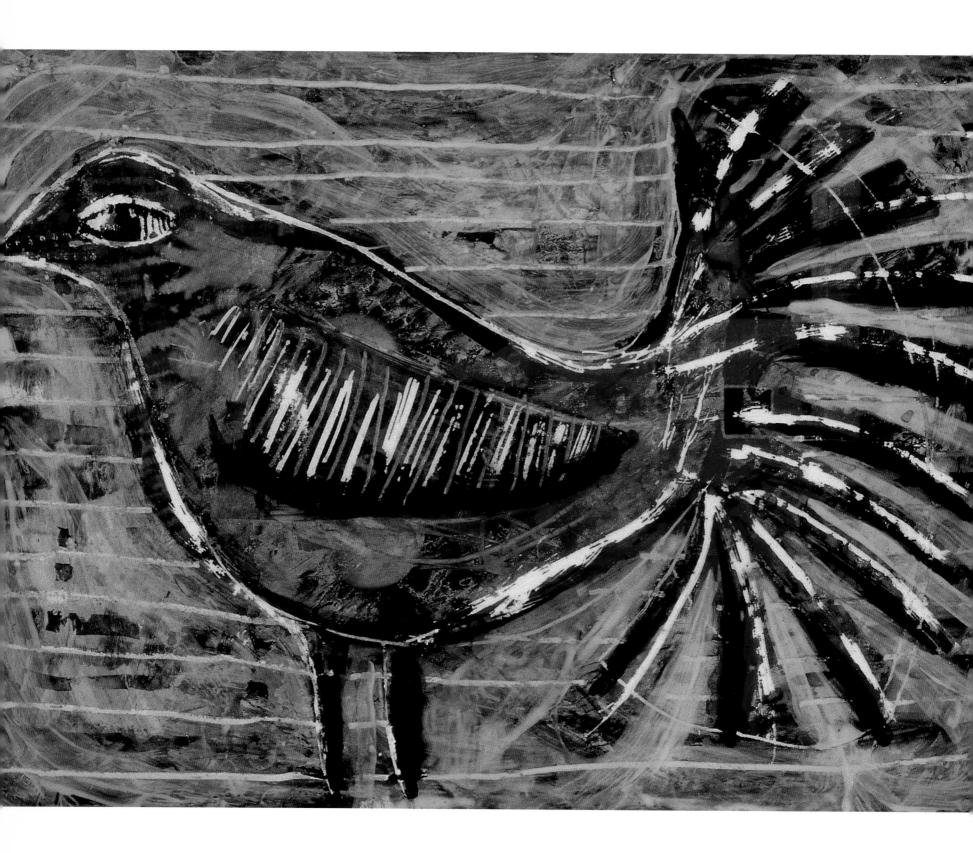

T never had to become
a feminist;
T was born liberated.

Grace Slick

One is not born a woman, one becomes one.

Simone de Beauvoir

he especial genius of women

I believe to be electrical in movement,
intuitive in function, spiritual in tendency.

Margaret Fuller

Once you live with the issue of WOMEN and the landscape for a while, you find that you cannot separate them from the notions of peace, spirituality, and community.

As women we must learn to become leaders in society,

not just for our own sake, but for the sake of all people.

We must support and protect our kinship with the environment

for the generations to come.

China Galland

It's all right for a woman to be, above all, human. I am a woman first of all.

Anaïs Nin

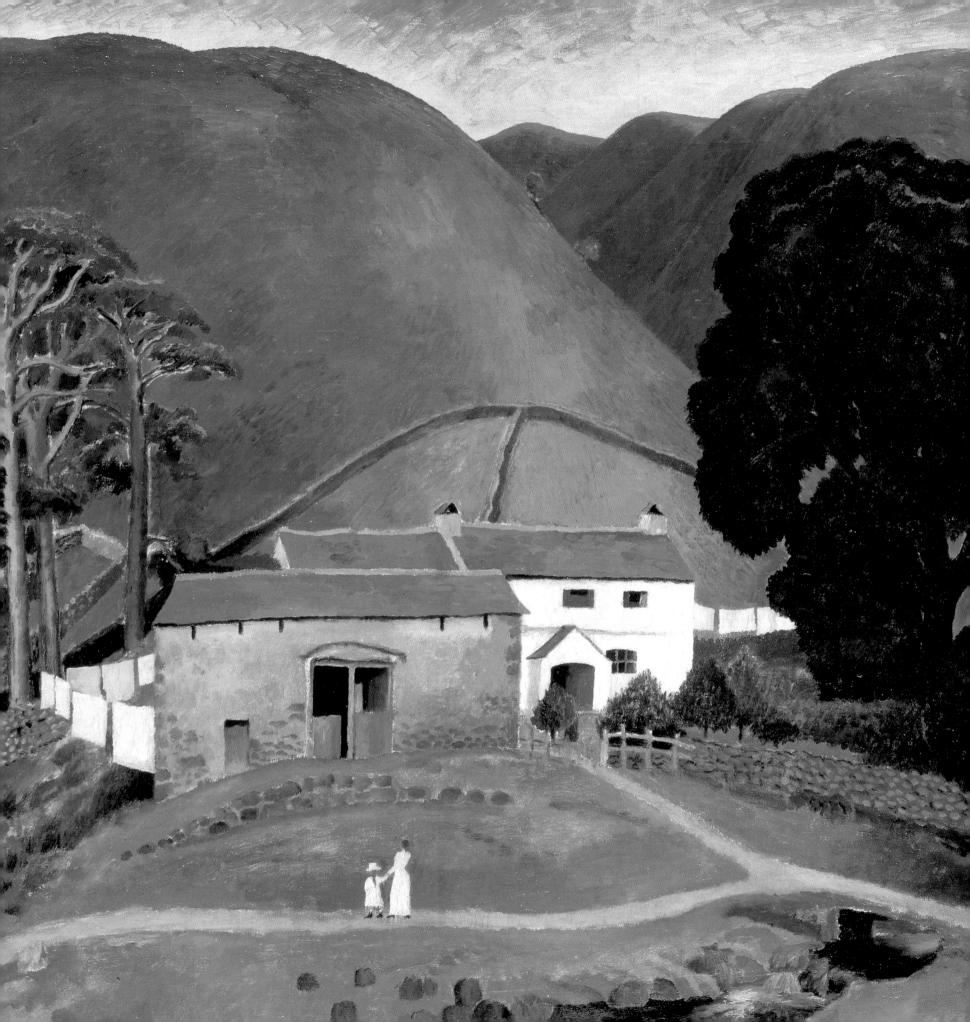

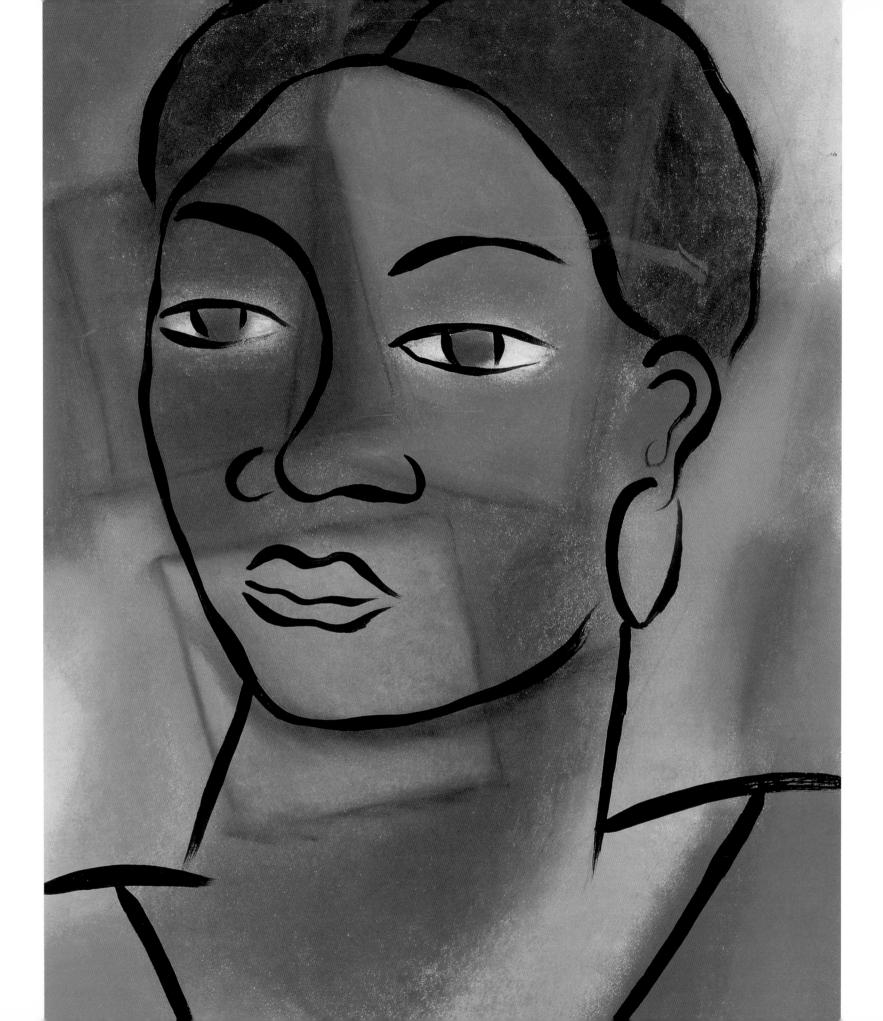

woman can do anything. She can be traditionally feminine and that's all right; she can work, she can stay at home; she can be aggressive, she can be passive; she can be anyway she wants with a man. But whenever there are the kinds of choices there are today, unless you have some solid base, life can be frightening.

Barbara Walters

A woman may develop wrinkles and cellulite, lose her waistline, her bustline, her ability to bear a child, even her sense of humor, but none of that implies a loss of her sexuality, her femininity...

Barbara Gordon

omen are never what they
seem to be.
There is the woman
you see and
the woman who is hidden.

Erma Bombeck

She had always to tell him all she thought and felt, knowing by some intuition of her own womanhood that no man wants to know everything ot any woman.

Pearl S. Buck

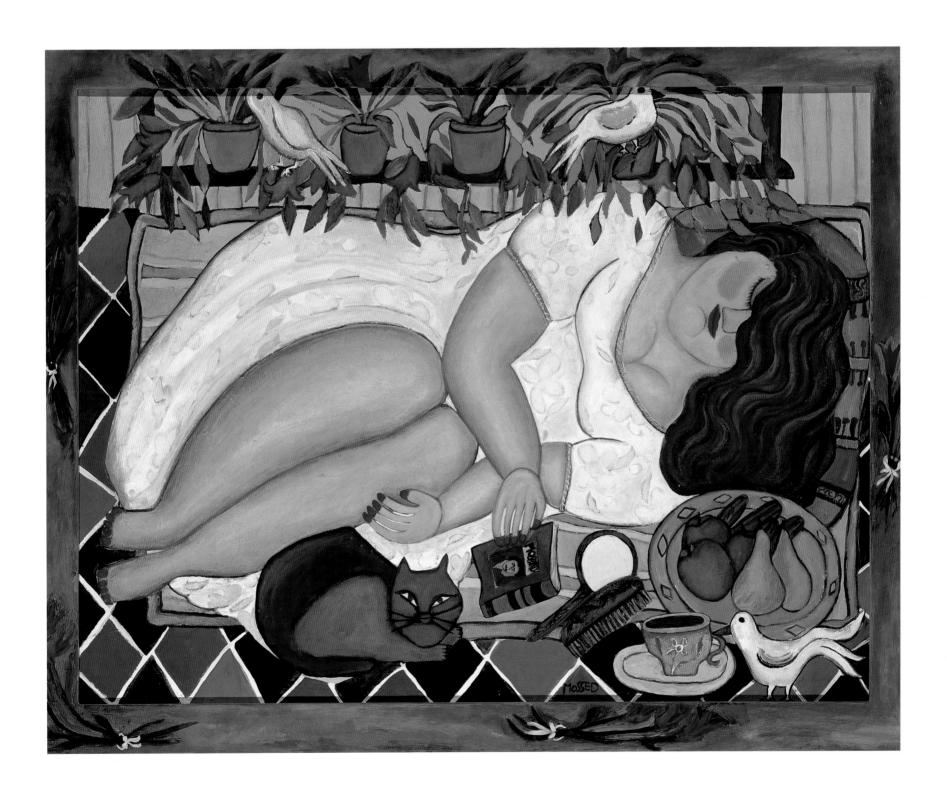

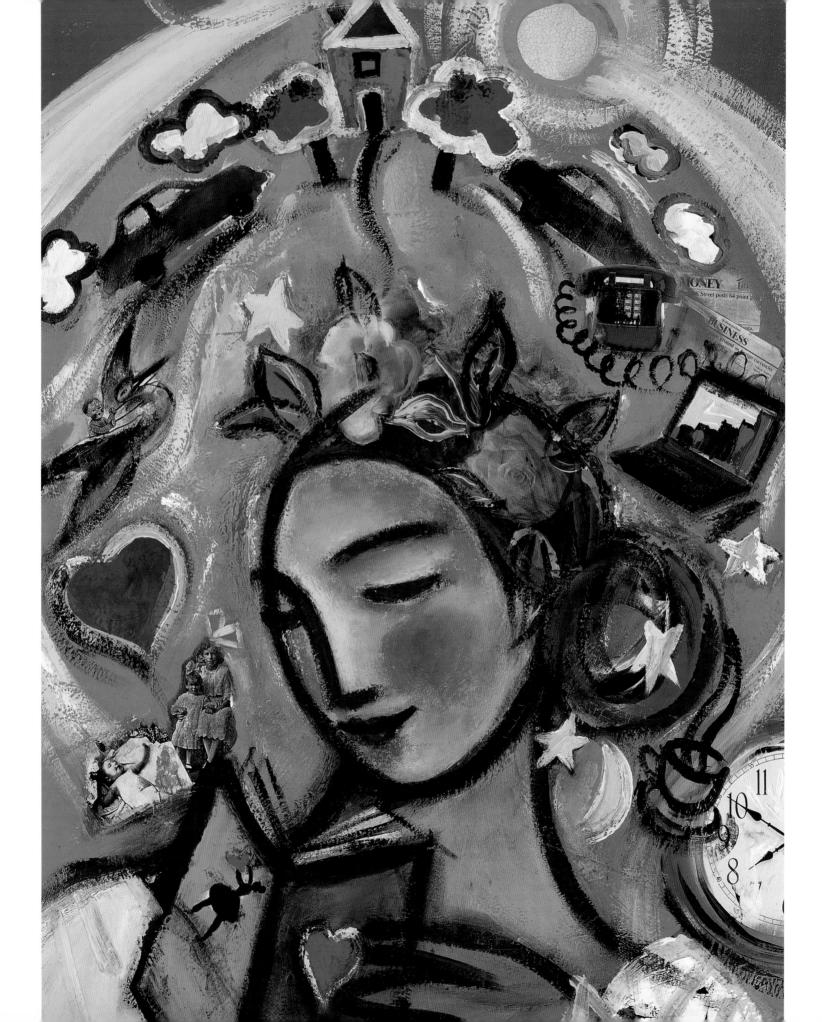

Being a Woman • Ambition and Challenge • Love and Relations • Creativity • Ambition and Spirituality • Being a Woman • Ambition and Challenge • Love and Relations Creativity
 Joy
 Maturing
 Dreams and Spirituality
 Being a Woman Ambidon and Challerge . Love and Relations . Creativity . Joy . Maturing .) Dreams and Spirituality •Being a Woman • Ambition and Challenge • Love and ativity . Joy . Naturing . Dreams and Spirituality . Being a an • Amb lion and Challen le • Love and R lations (Creative st Love and Relations st Creativity st Joy st Maturing st Dreams and Spirituality stBeing a Woman • Ambition and Challenge • Love and Relations • Creativity • Joy • Maturing • Dreams and Spirituality • Being a Woman • Ambition and Challenge • Love and Relations • Creativity • Joy • Maturing • Dreams and Spirituality • Being a Woman • Ambition and Challenge • Love and Relations Creativity
 Joy
 Maturing
 Dreams and Spirituality
 Being a Woman Ambition and Challenge . Love and Relations . Creativity . Joy . Maturing . Dreams and Spirituality • Being a Woman • Ambition and Challenge • Love and Relations • Creativity • Joy • Maturing • Dreams and Spirituality • Being a woman · Ambition and Challenge · Love and Relations · Creativity · Joy ·

Jomen have been called queens for a long time, but the kingdom given them isn't worth ruling.

Louisa May Alcott

None of us suddenly

becomes something overnight.

The preparations have

been in the making for a lifetime.

Gail Godwin

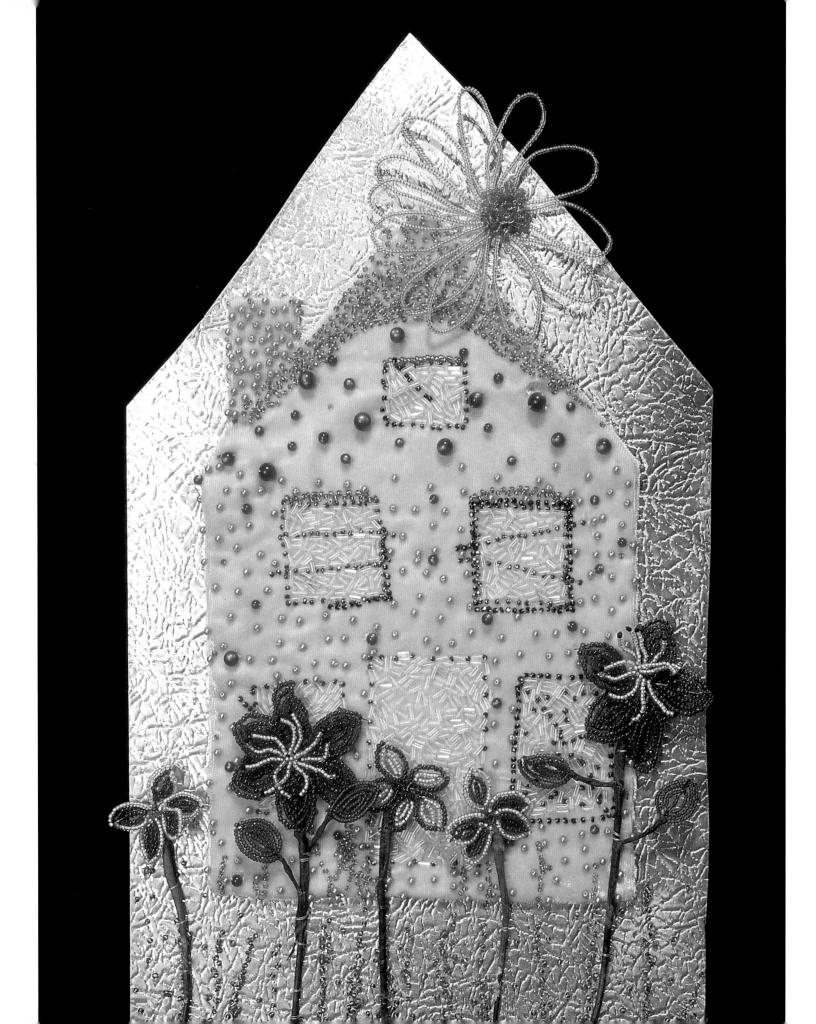

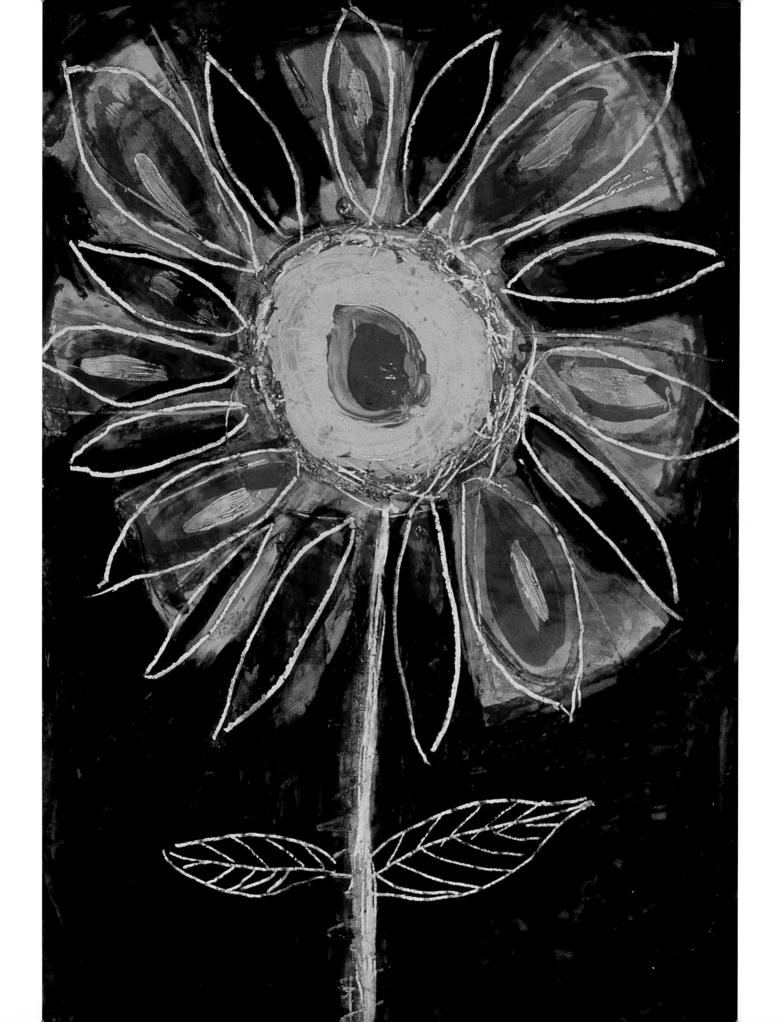

A woman's life can really be a succession of lives,

each revolving around some emotionally compelling situation or challenge, and each marked off by some intense experience.

Wallis Simpson

he challenge now is to practice politics as the art of making what appears to be impossible, possible.

Hillary Rodham Clinton

We all live in suspense,

from day to day, from hour to hour;

in other words,

we are the hero of our own story.

Mary McCarthy

There are so many doors to be opened,

and I'm not afraid to look behind them.

_____ Elizabeth Taylor

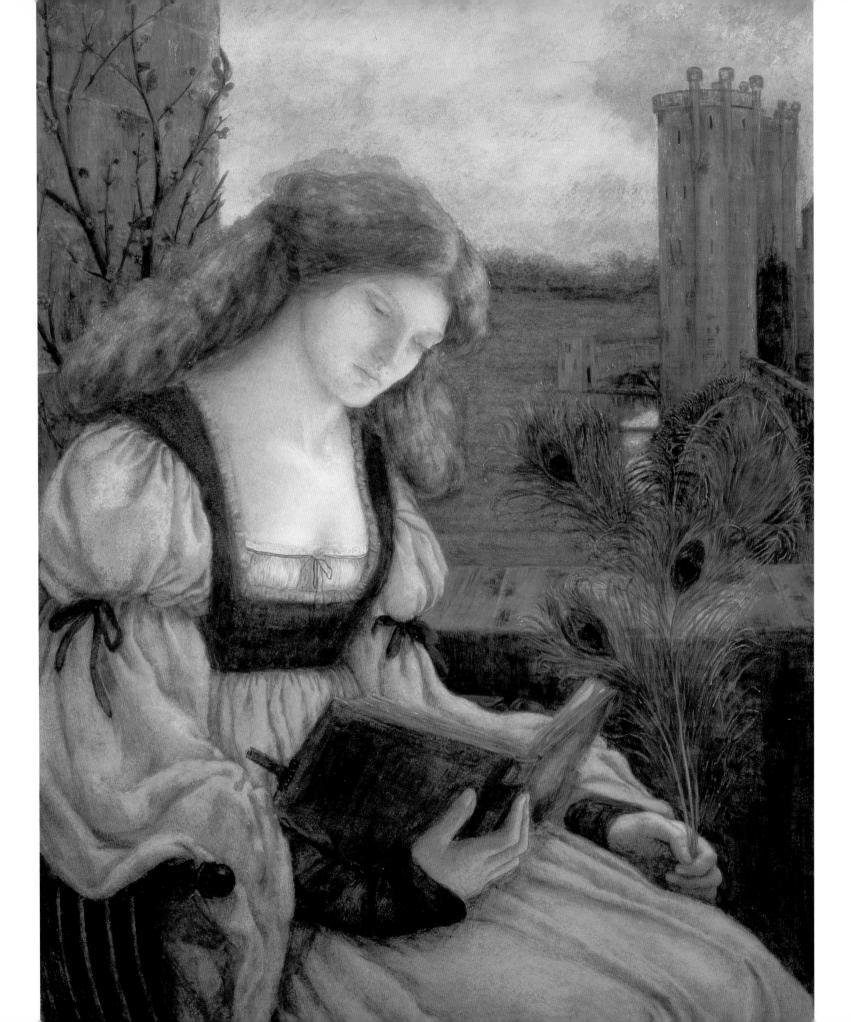

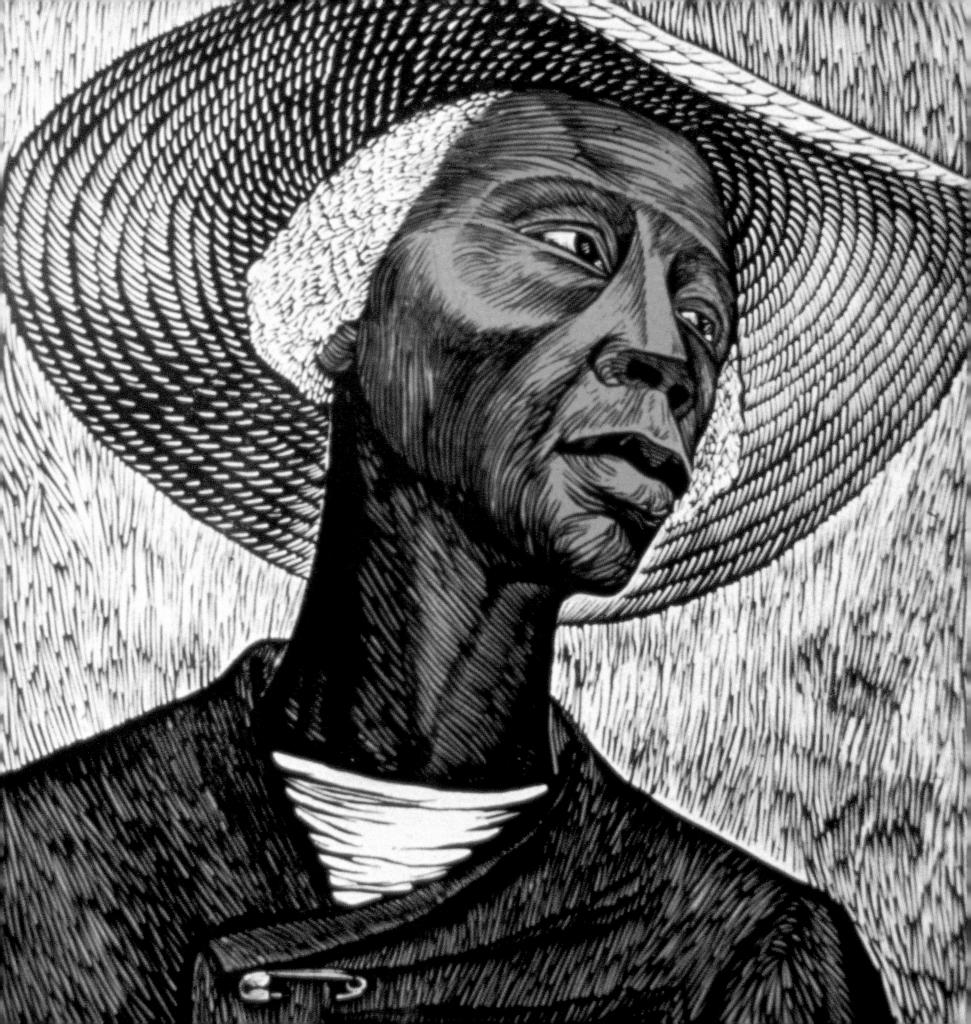

Forgiveness is the most important thing.

We all have to forgive what was done to us—
the Irish people have to forgive,
the African people, the Jewish people—
all have to forgive and understand.

The only way to stop the cycle of hate
and abuse is not to allow yourself
to get caught up in it.

I've had my share of pain, and I probably will in the future, too. But I've gotta say, it's sculpted me into the person I am now. There was a time when I looked to other people for recognition, because I didn't have enough confidence to trust my own judgment. Now I'm not looking for reassurance, because I realize how fickle people are: My own strength is the best strength I can have.

Annie Lennox

Life is to be lived.

If you have to support yourself,

you had bloody well

better find some way that

is going to be interesting.

And you don't do that by

sitting around wondering about yourself.

Katherine Hepburn

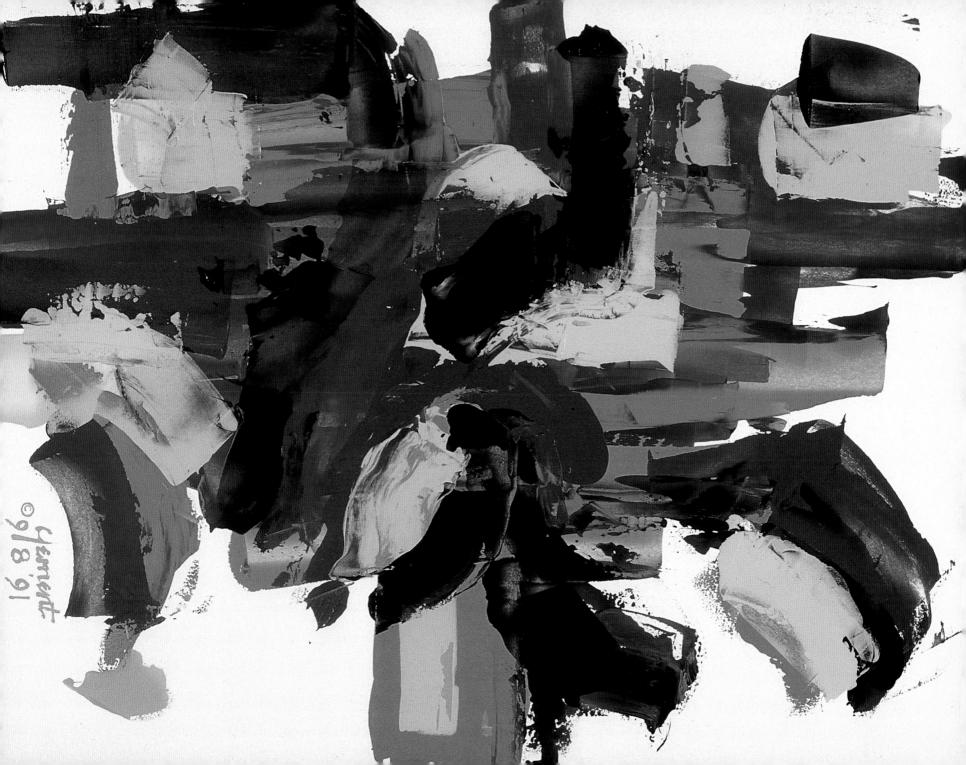

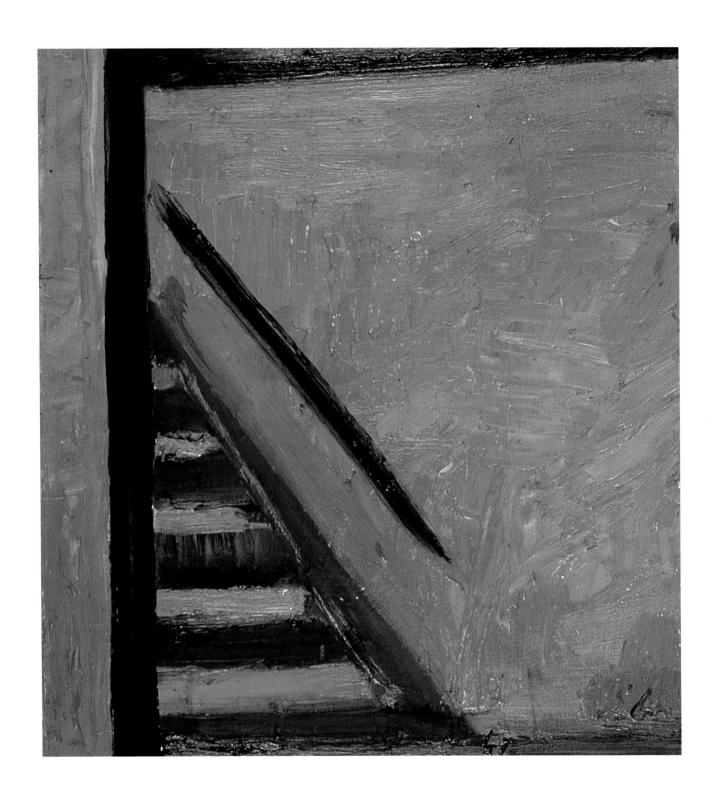

Everyone has talent. What is rare is the courage to follow the talent to the dark place where it leads.

Don't compromise yourself.
You are all you've got.

Janis Joplin

Erica Jong

The have only one real shot at liberation, and that is to emancipate ourselves from within.

Colette Dowling

I've always tried to go a step past wherever people expected me to end up.

Beverly Sills

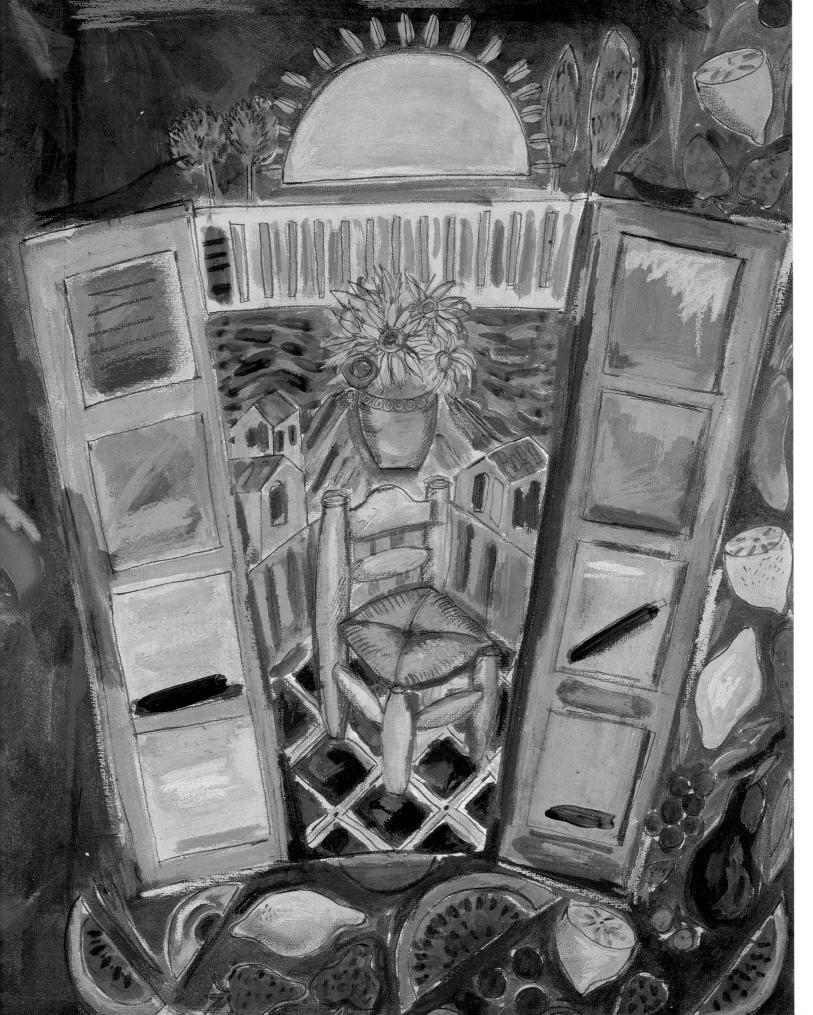

It's hard to stay committed... to stay in touch with the goal without saying there's something wrong with myself, my goal, the world.

Nancy Hogshead

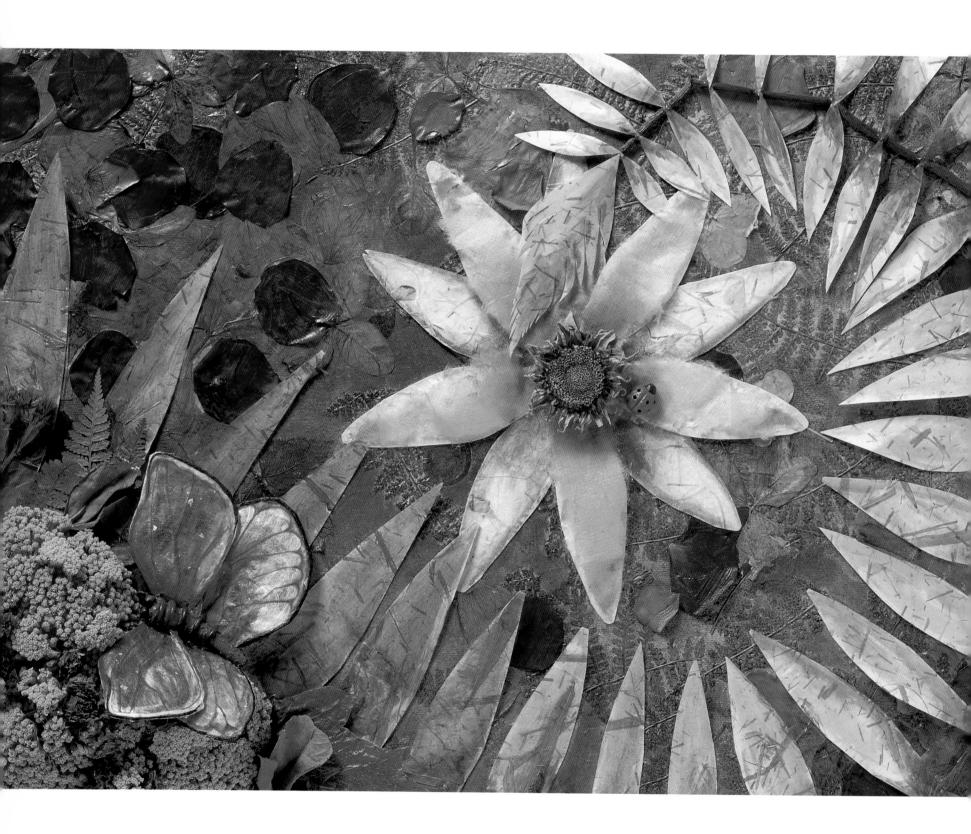

Prejudices, it is well known,

are most difficult to eradicate from the heart whose

soil has never been loosened

or fertilized by education: they grow there,

firm as weeds among stones.

Charlotte Brontë

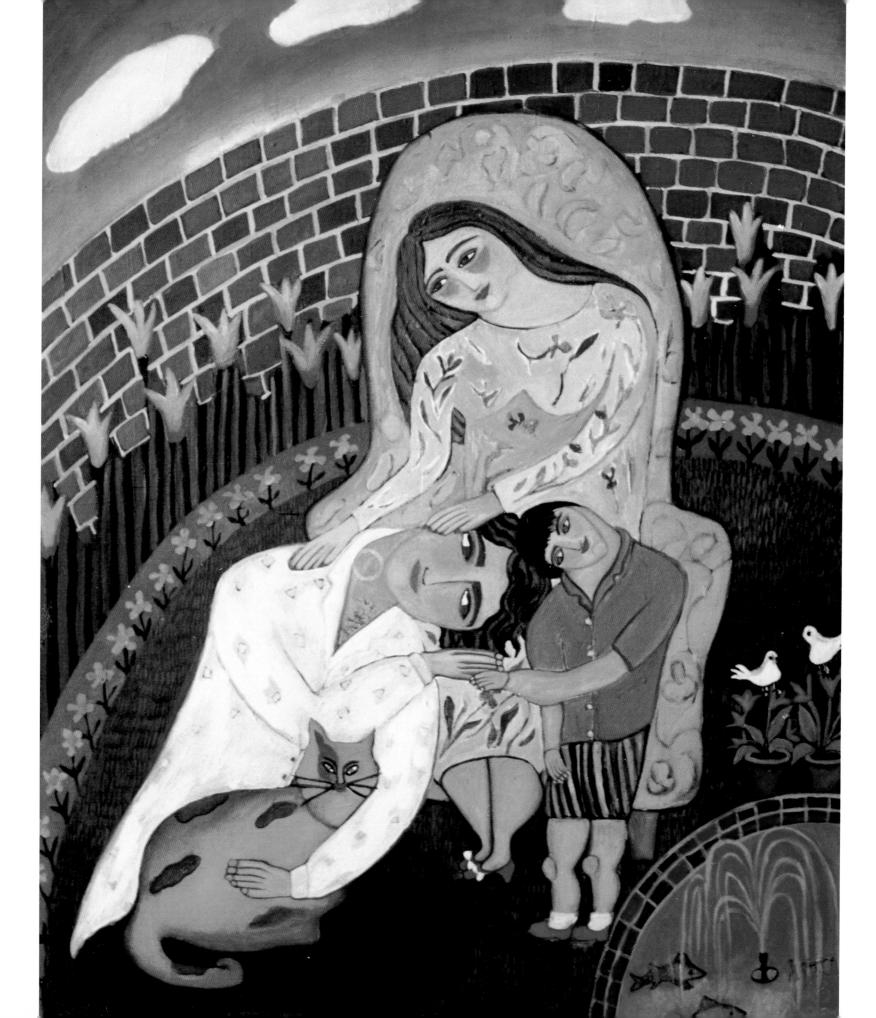

Being a Woman • Ambition and Challenge • Love and Relations • Creativity • challenge • Love and Relations • Creativity • Joy • Maturing • Dreams and Spirituality • Being a Woman • Ambition and Challenge • Love and Relations Creativity • Joy • Maturing • Dreams and Spirituality • Being a Woman • Ambition and Challenge • Love and Relations • Creativity • Joy • Maturing • Dreams and Spirituality •Being a Woman • Ambition and Challenge • Love and Relations • Creativity • Joy • Maturing • Dreams and Spirituality • Being a voman • Ambition and Challenge • Love and Relations • Creativity • Joy • Love and Relations . Creativity . Joy . Maturing . Dreams and Spirituality . Being a Woman • Ambition and Challenge • Love and Relations • Creativity • Challenge • Love and Relations • Creativity • Joy • Maturing • Dreams and ion and Challenge . Love and Relations . Creativity . Joy . Maturing . Crezitiv ty (* John that uting * Dealts and Spin uality a Woman · Ambition and Challenge · Love and Relations · Creativity · Joy ·

I don't need a man to rectify my existence.

The most profound relationship

we'll ever have is the one with ourselves.

Shirley MacLaine

Joy is a net of love by which you can catch souls.

Mother Teresa

It bugs me to have people who are obsequious.

If someone's humoring or manipulative, I won't have it.

The truth I can handle. I can't handle

not knowing what they're thinking or feeling.

Jodie Foster

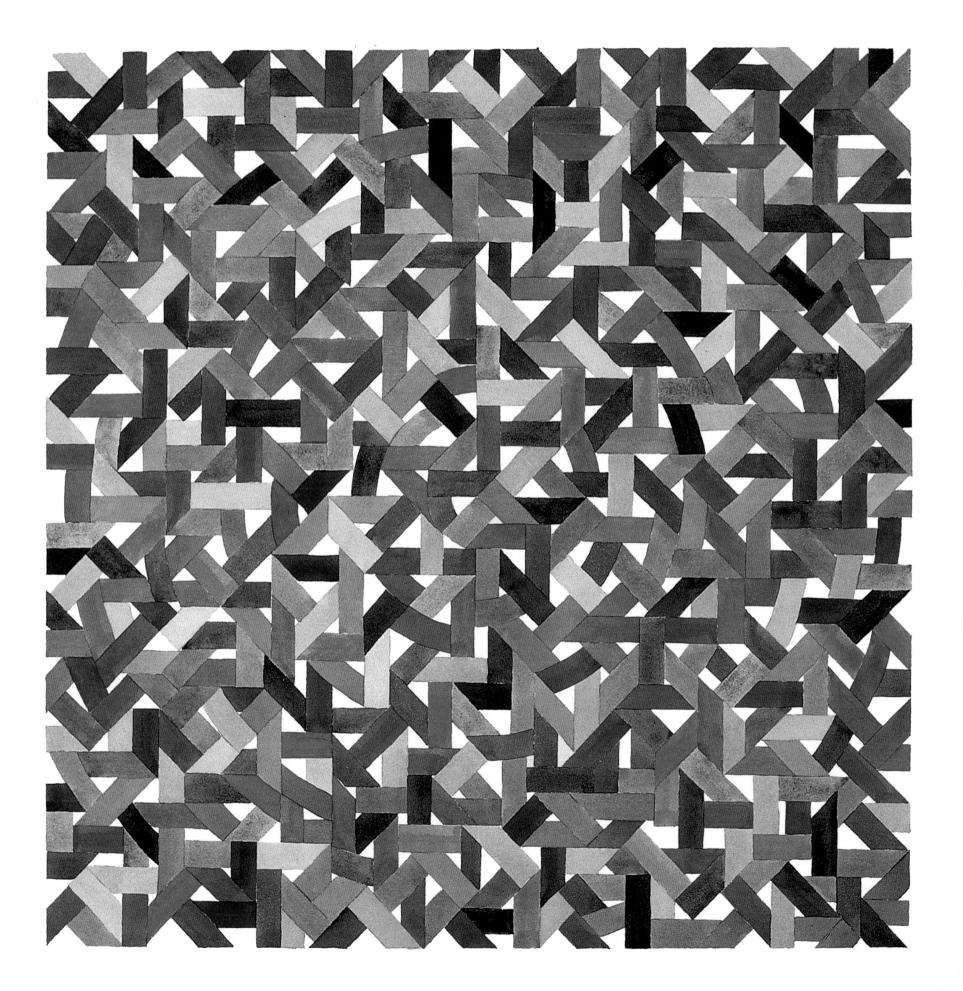

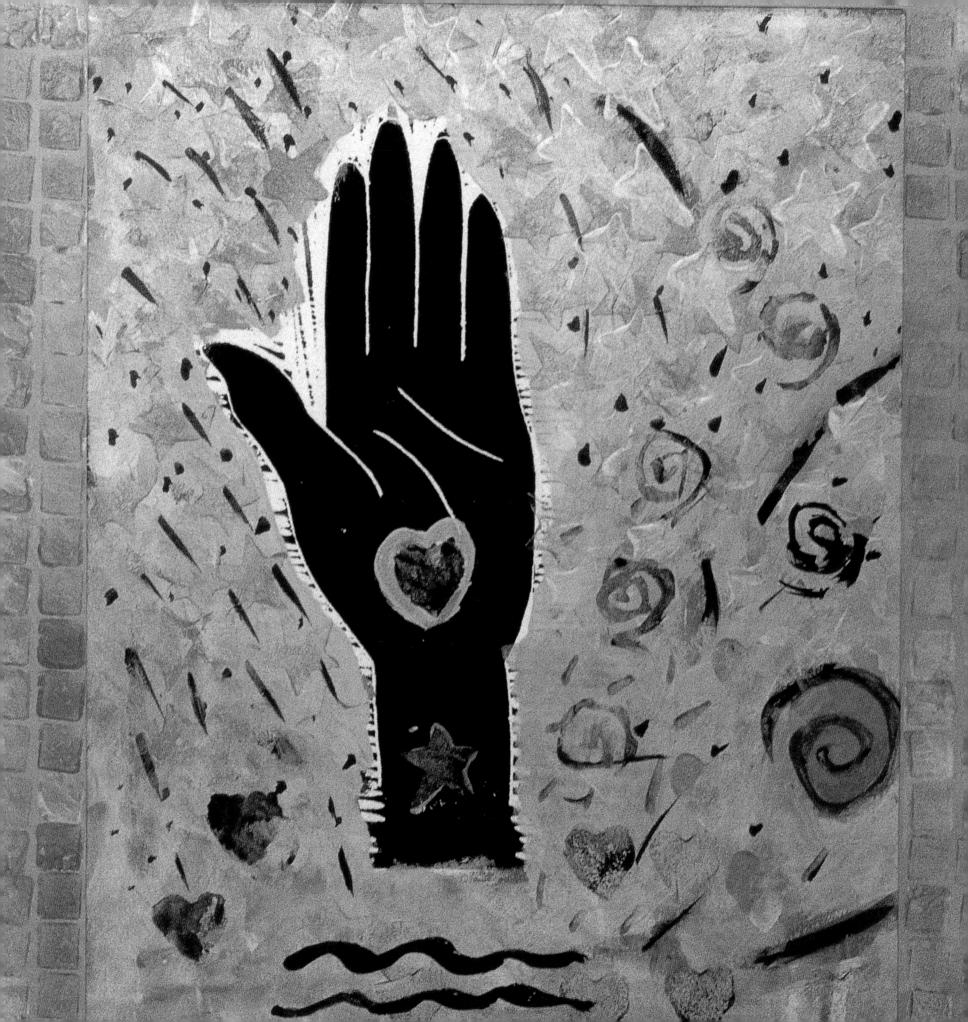

was at a party feeling very shy because there were a lot of celebrities around, and I was sitting in a corner alone and a very beautiful young man came up to me and offered me some salted peanuts and he said, 'I wish they were emeralds' as he handed me the peanuts and that was the end of my heart. I never got it back.

Helen Hayes

It is the friends you can call up at 4 A.M. that matter.

Marlene Dietrich

The Eskimo has fifty-two names for snow

because it is important to them;

there ought to be as many for love.

Margaret Atwood

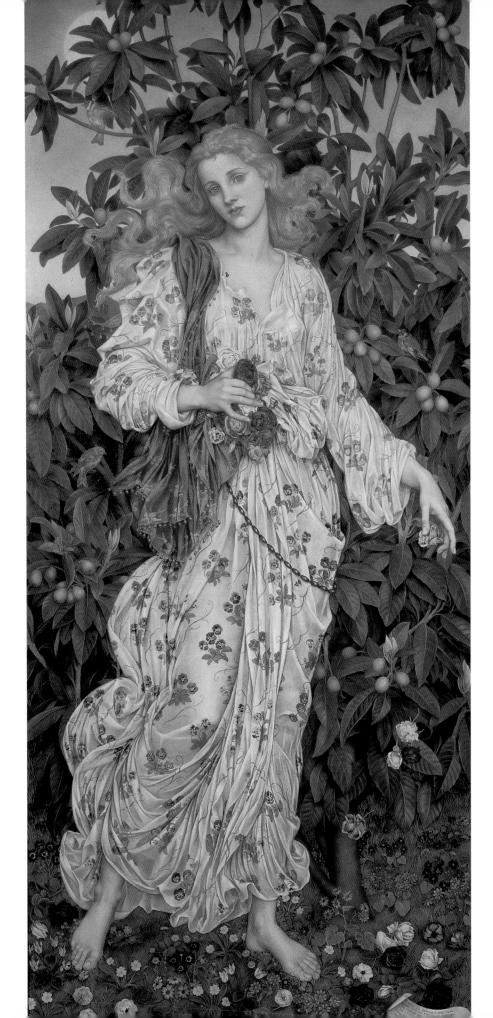

The more

Twonder...

the more

Hove.

Alice Walker

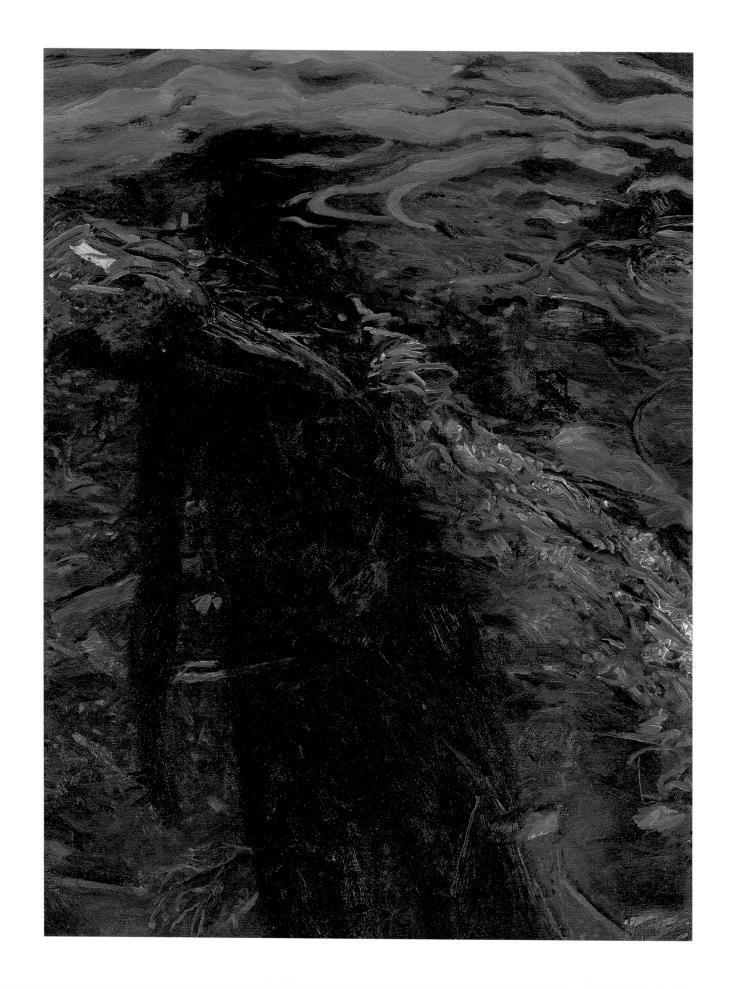

and if you don't share it,
you don't give the person who
loves you enough
chance to love you enough.

If IOVE is the answer,

could you please
rephrase the QUESTION?

Lily Tomlin

Love is a game that two can play and both win.

Eva Gabor

We measure success

and depth by length of time,

but it is possible to have

a deep relationship that

doesn't always stay the same.

Barbara Hershey

Love is a fire. But whether it is going to Warm your heart or burn down your house, you can never tell.

Joan Crawford

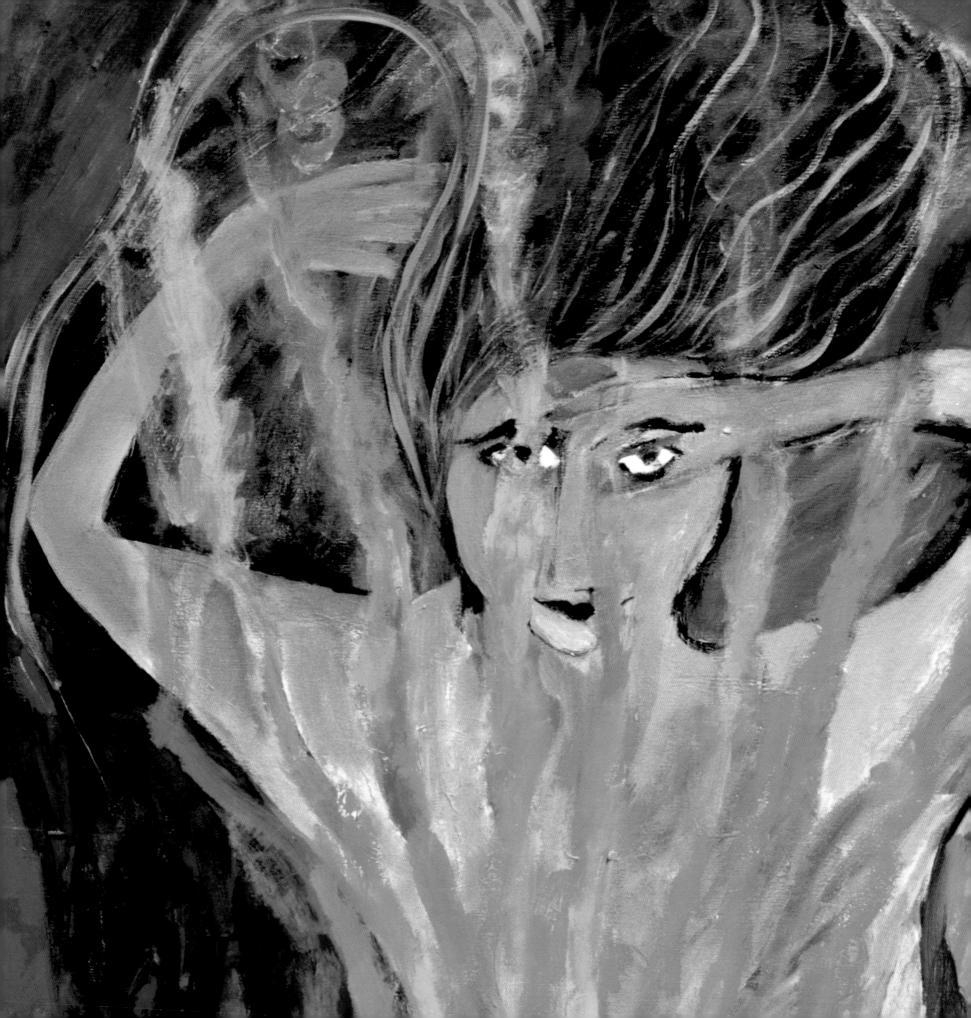

Each contact with

a human being is so rare,

so precious,

one should preserve it.

Anaïs Nin

Chains

do not

hold a

marriage

together.

It is threads,

hundreds

of tiny

threads,

which sew

people

together

through

the years.

Simone Signoret

Marriage is not just spiritual communion

and passionate embraces;

marriage is also three meals a day,

sharing the workload and

remembering to carry out the trash.

Dr. Joyce Brothers

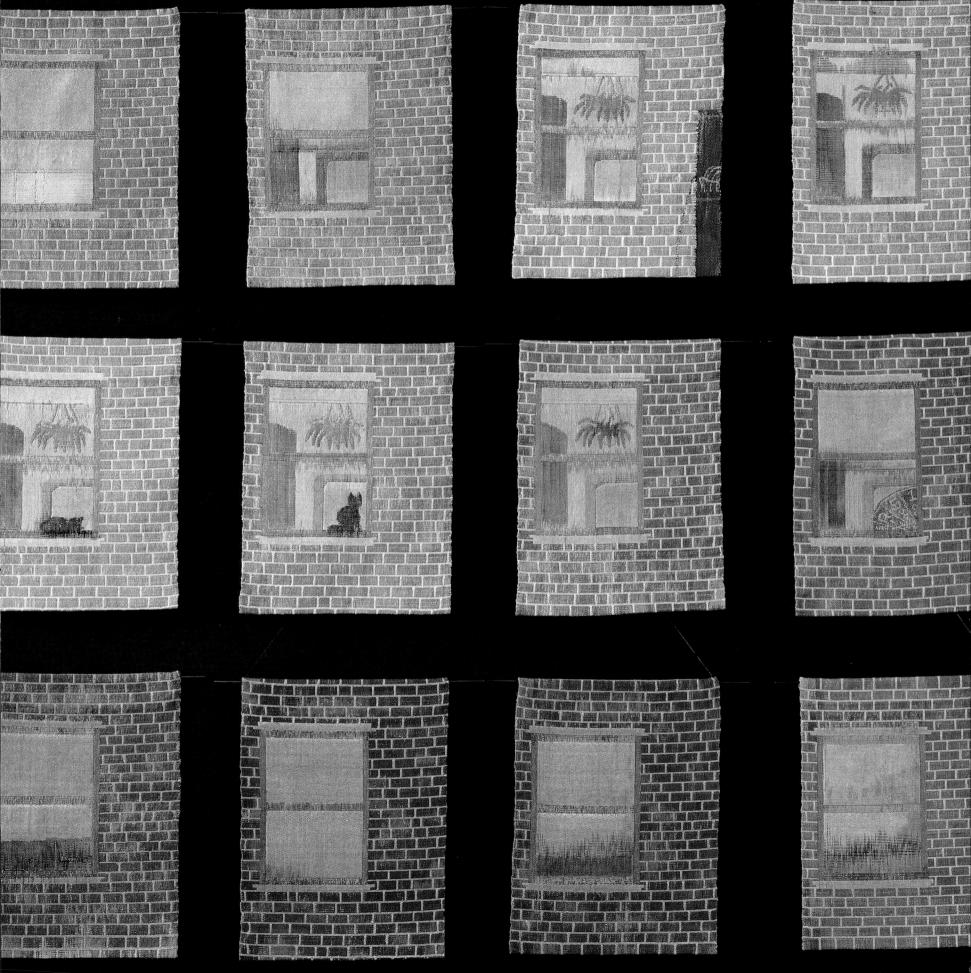

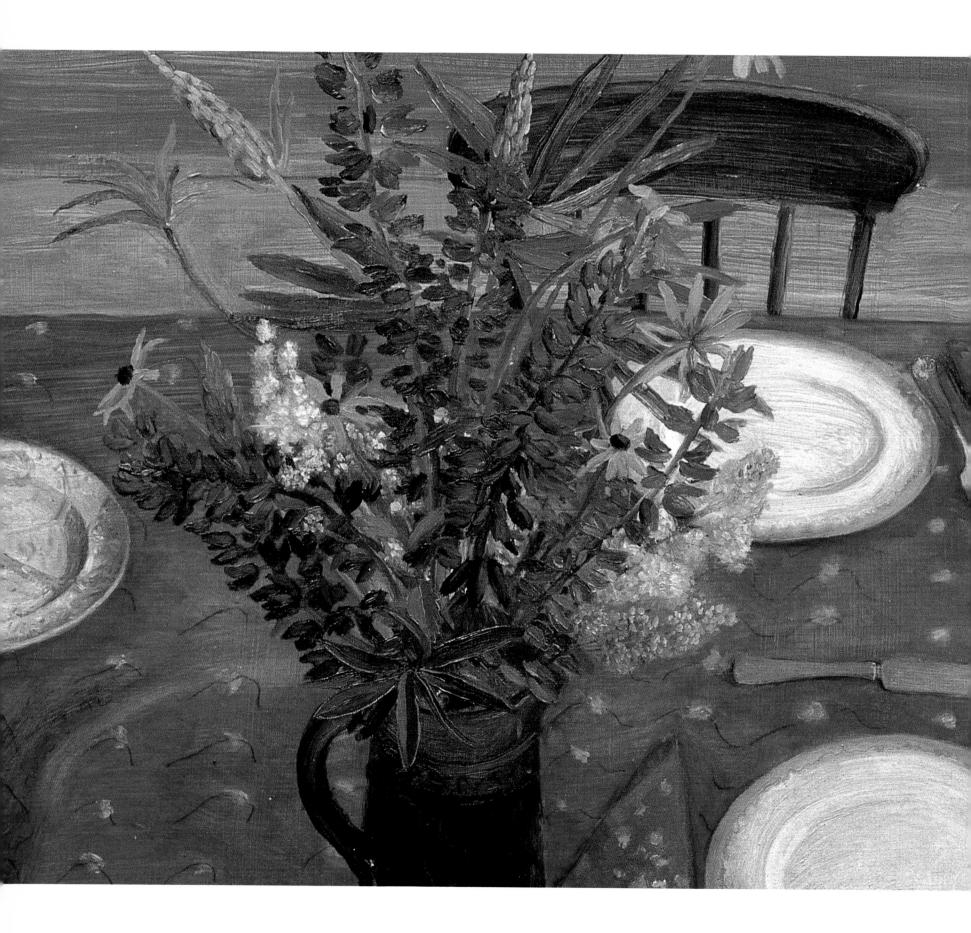

...Love from one being to another can only be that two solitudes

come nearer, recognize and protect

and comfort each other.

Han Suyin

I'd rather have roses on my table than diamonds on my neck.

Emma Goldman

Do not seek the because—in love there is no because, no reason, no explanation, no solutions.

Anaïs Nin

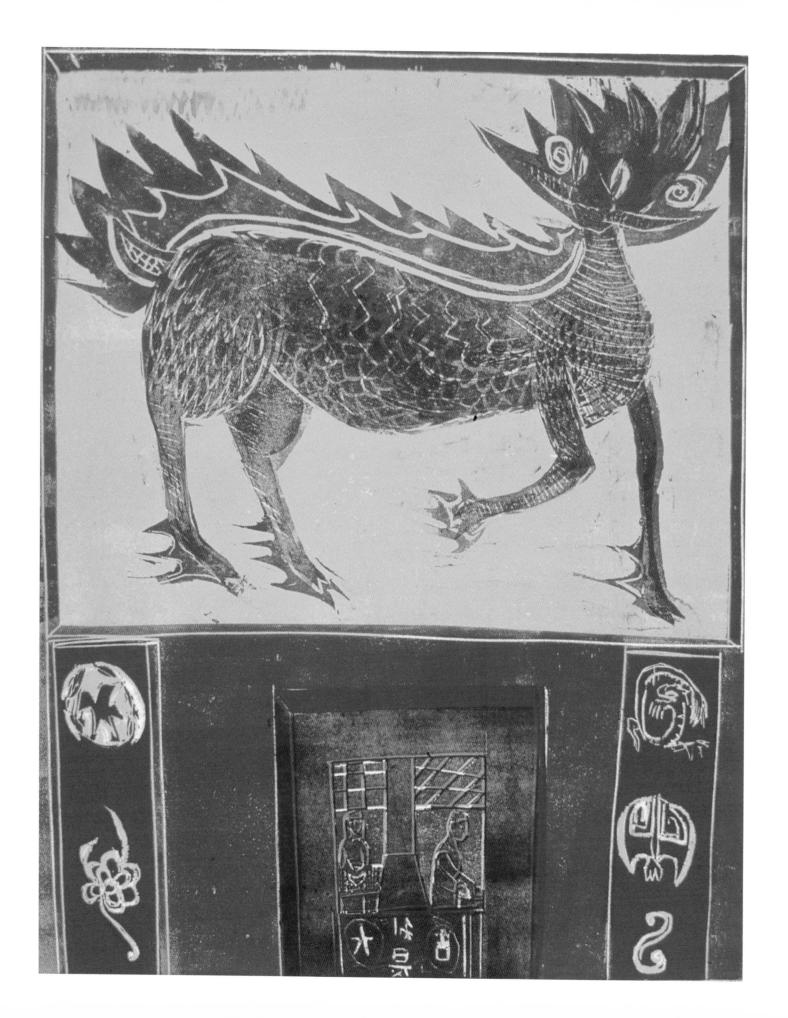

Being a Woman • Ambition and Challenge • Love and Relations • Creativity • Challenge • Love and Relations • Creativity • Joy • Maturing • Dreams and Creativity • Joy • Maturing • Dreams and Spirituality • Being a Woman • Ambilion and Challenge • Love and Relations • Creativity • Joy • Maturing •1 Relations • Creativity • Joy • Maturing • Dreams and Spirituality • Being a Woman • Ambition and Challenge • Love and Relations • Creativity • Joy • J Love and Relations • Creativity • Joy • Maturing • Dreams and Spirituality • Being a Woman • Ambition and Challenge • Love and Relations • Creativity • enge . Love and Relations . Creativity . Joy . Maturin, spirituality • Bong a worken Amarion and Thallenge • Love and Relations
• Creativity • 10, Sampling Dear and Epirituality • Bong o Woylen • Ambition and Challenge • Love and Relations • Creativity • Joy • Maturing • and Relations • Creativity • Joy • Maturing • Dreams and Spirituality • Being a Woman · Ambition and Challenge · Love and Relations · Creativity · Joy •

Creativity can be described as letting go of certainties.

Gail Sheehy

Original thought is like original sin:

both happened before

you were born to people you could

not possibly have met.

Fran Lebowitz

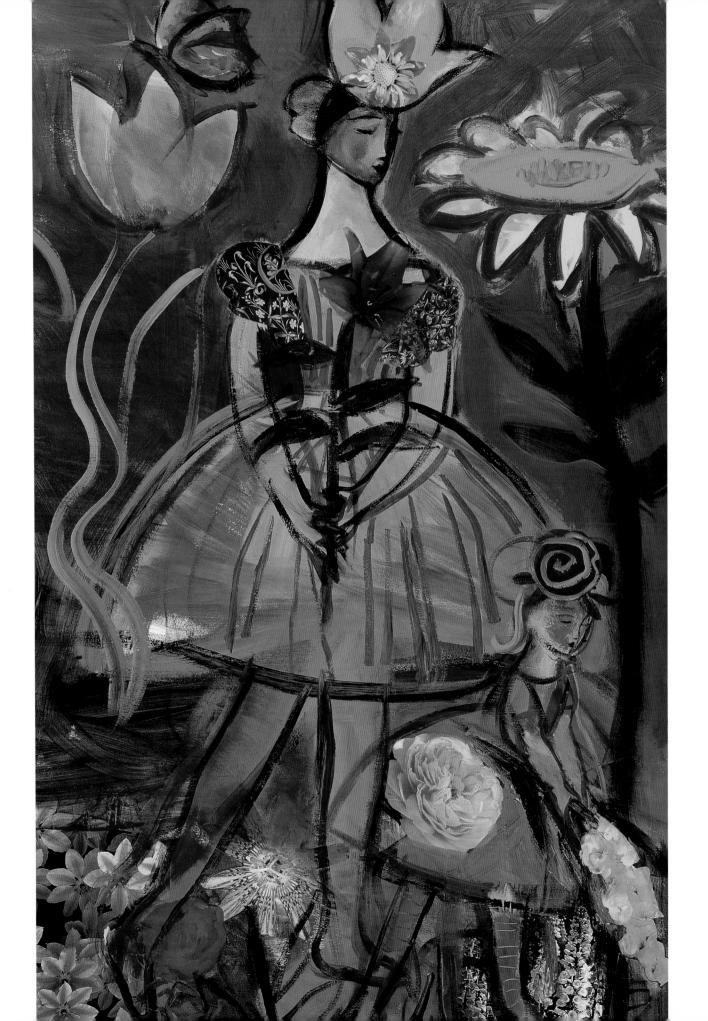

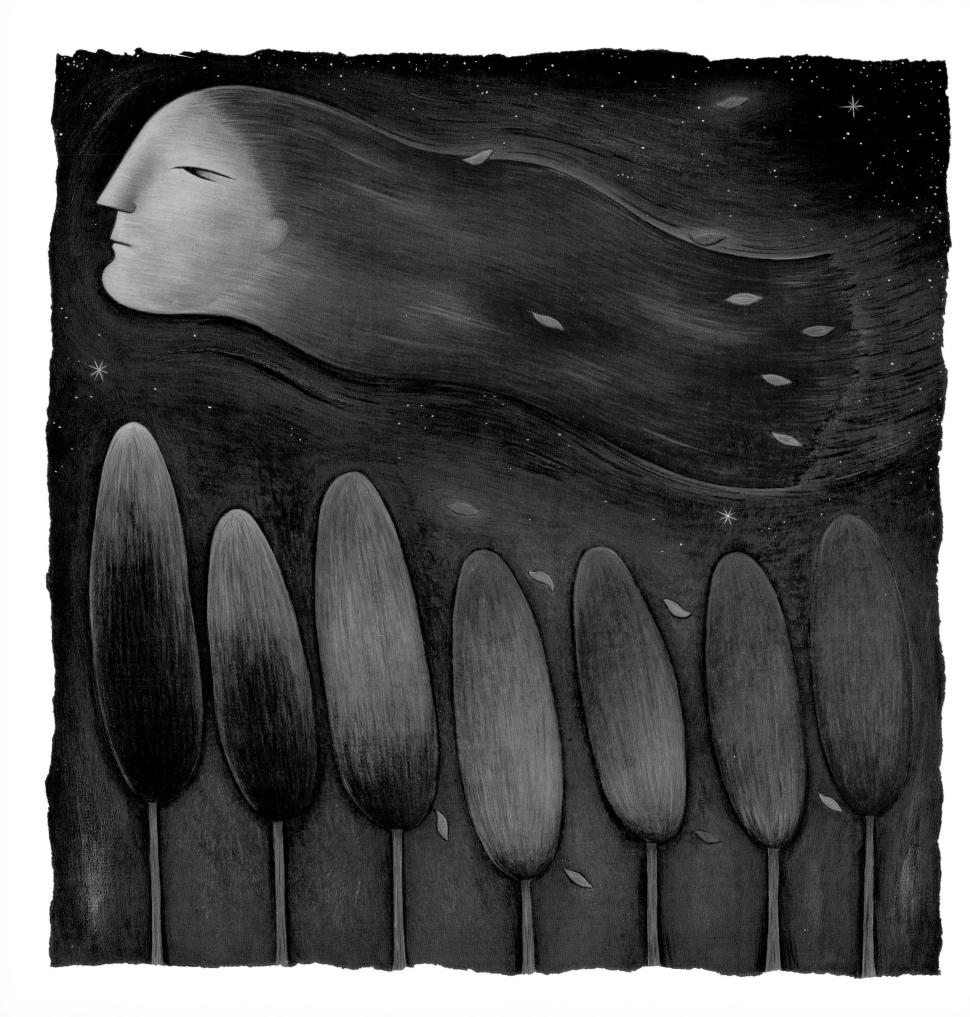

It is wonderful to be

in on the

creation of something,

see it used,

and then walk away and smile at it.

Lady Bird Johnson

The excitement, the true excitement, was always in starting again.

Nothing's worse than an accomplished task, a realized dream.

Marilyn Harris

...the artist

is not there

to be at

one with the

world, he

is there to

transform it.

Anaïs Nin

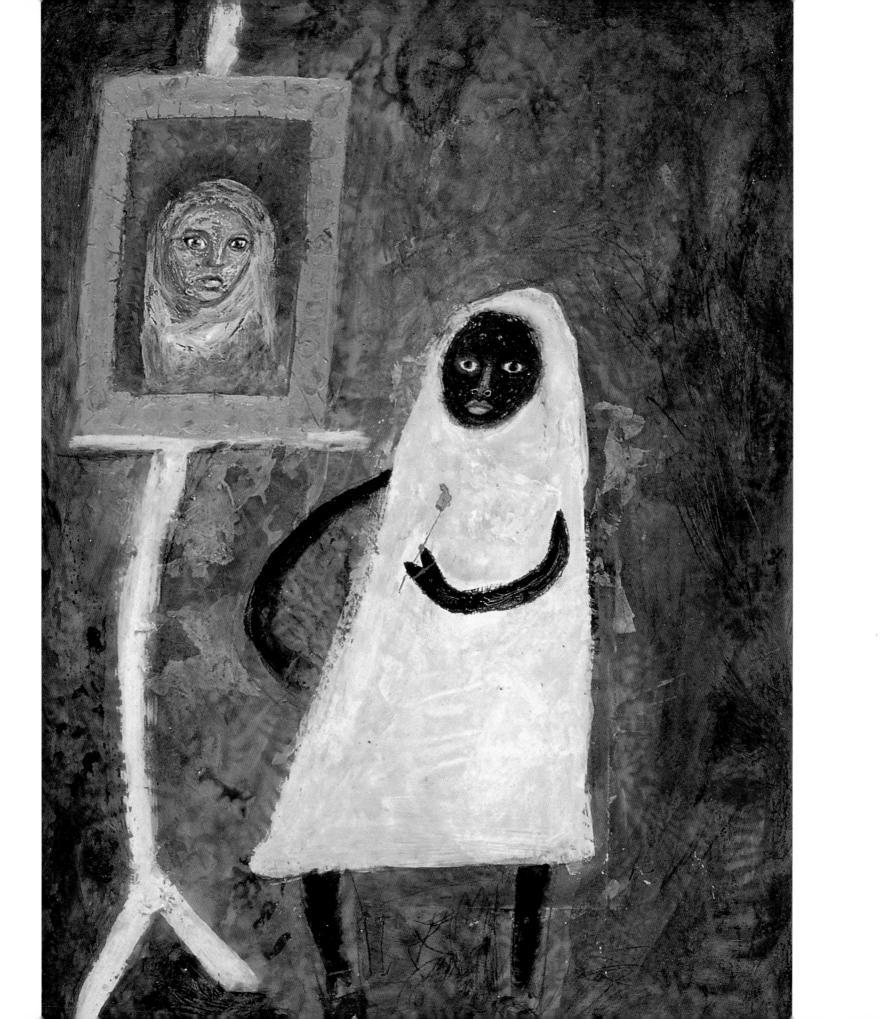

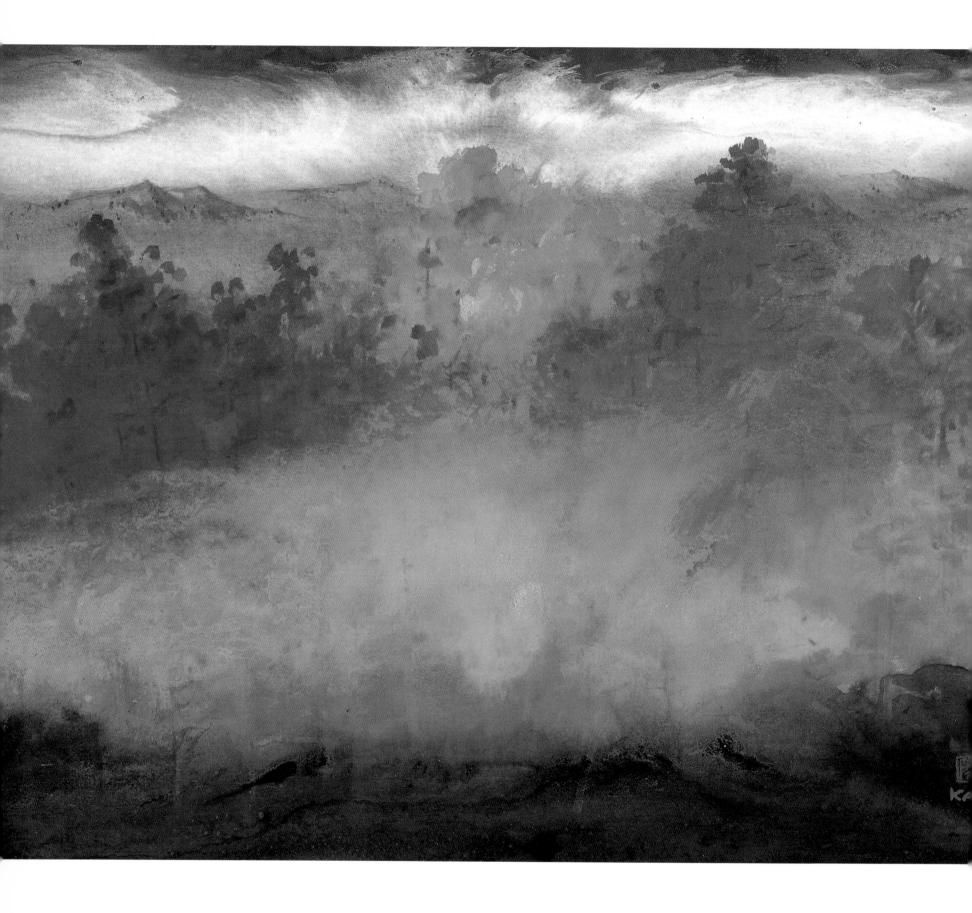

Some of us come on earth seeing—some of us come on earth seeing color.

Louise Nevelson

I believe that to Create one's own world in any

of the arts takes COUrage.

Georgia O'Keefe

e are stimulated to emotional response not by works that confirm our sense of the world, but by works that challenge it.

Joyce Carol Oates

It takes

a lot of

time being

a genius,

you have

to sit

around so

much doing

nothing.

Gertrude Stein

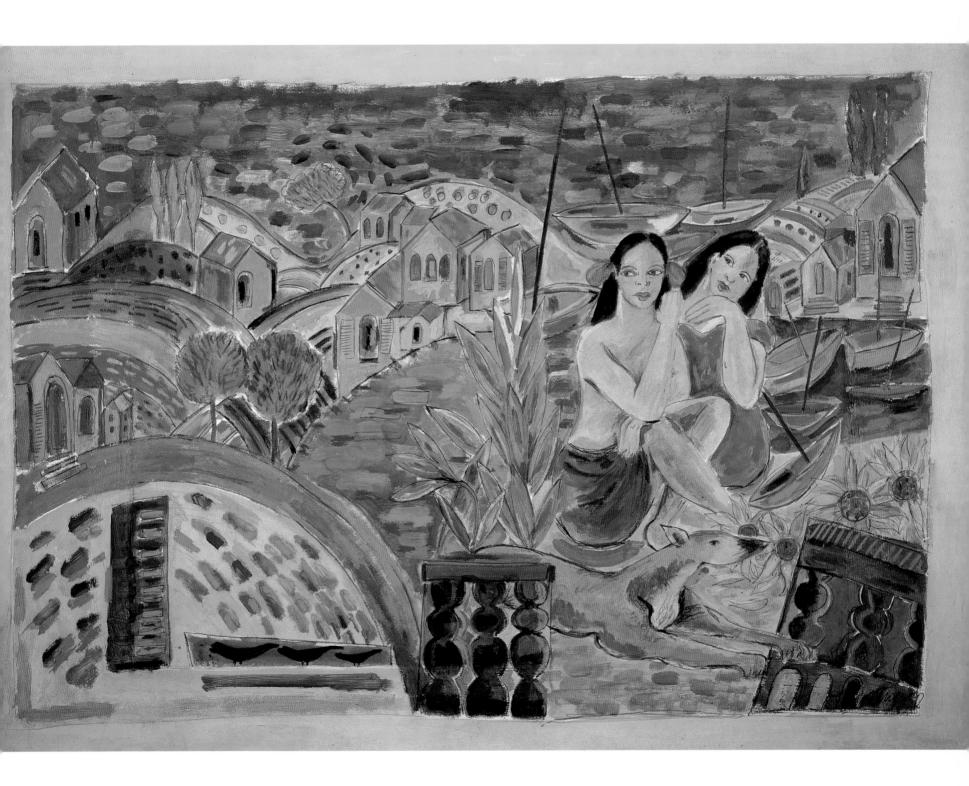

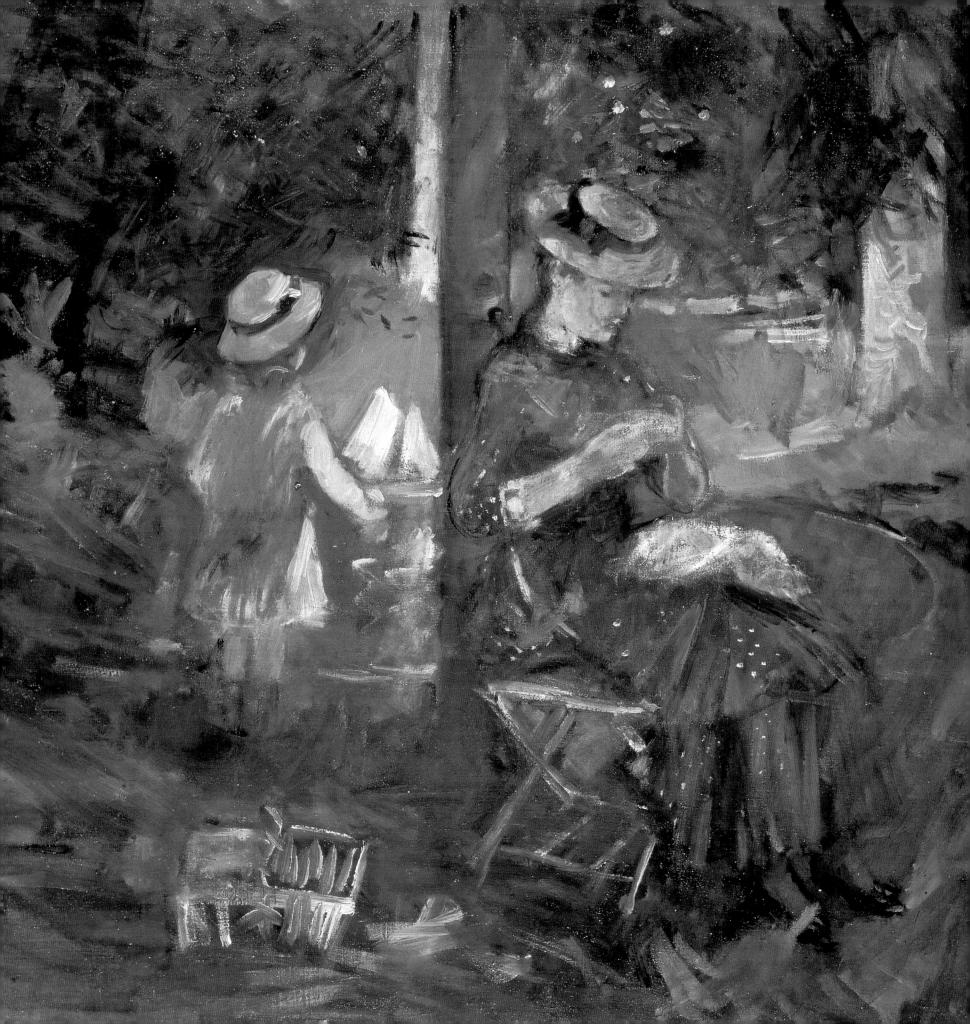

Imagination is the highest kite one can fly.

Lauren Bacall

ne wonders what would happen in a society in which there were no rules to break.

Doubtless everyone

would quickly die of boredom.

Susan Howatch

Creative minds have always been

known to SUTVIVE any kind of bad training.

Anna Freud

All prosperity begins in the mind and is dependent only upon the full use of our creative imagination.

Ruth Ross

alent is like electricity. We don't understand electricity. We use it.

You can plug into it and light up a lamp, keep a heart pump going,
light a cathedral, or you can electrocute a person with it.

Maya Angelou

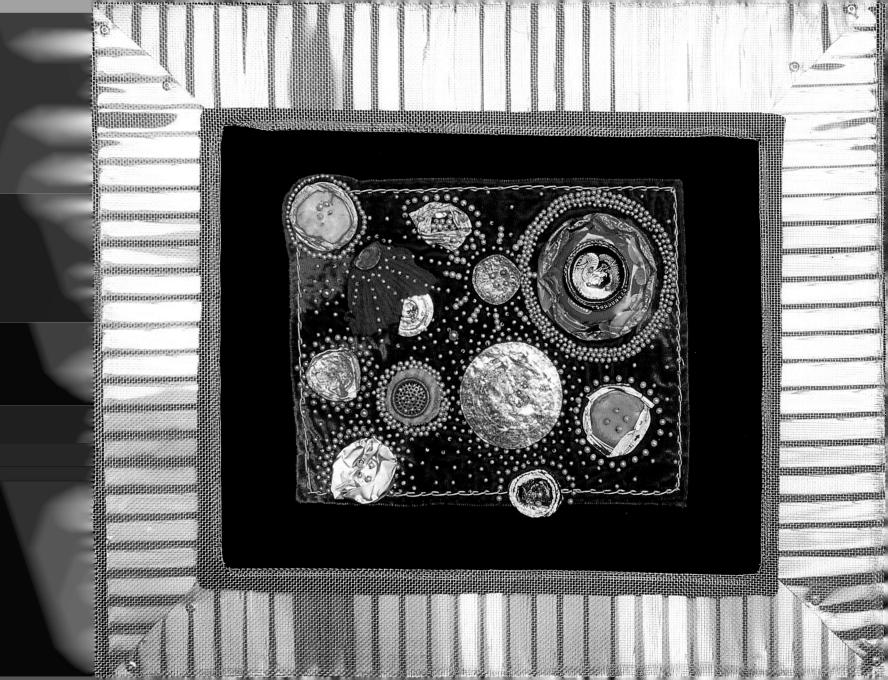

A good idea will keep

you awake during the morning,

but a great idea will

keep you awake

during the night.

Marilyn Vos Savant

Want is the mistress of invention.

Susannah Centilivre

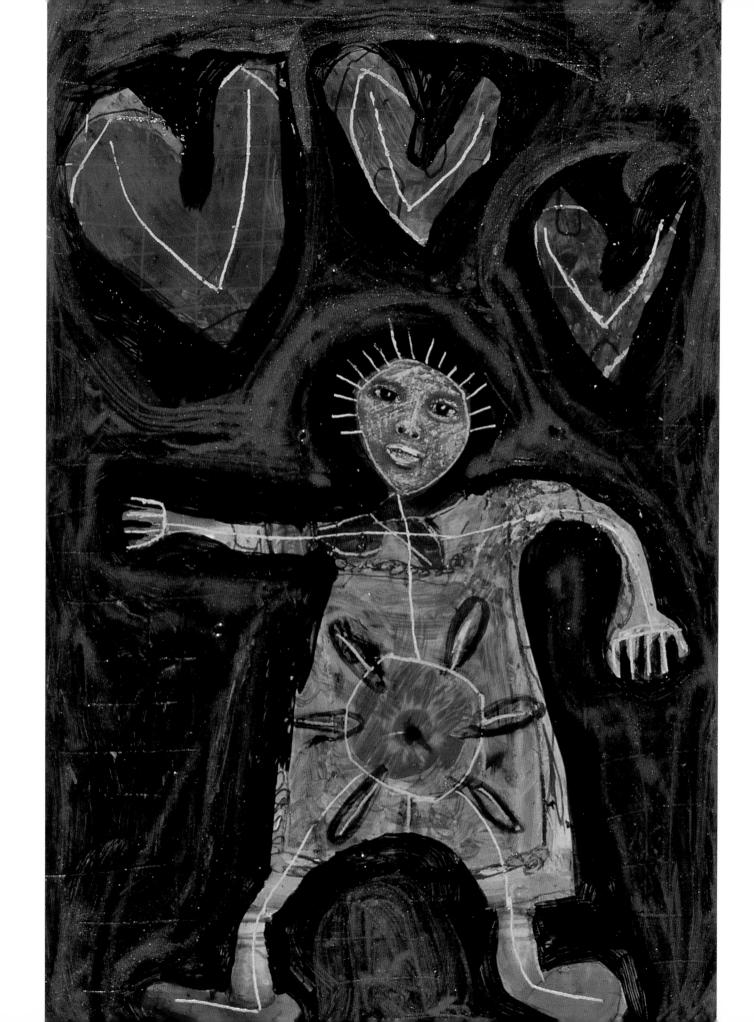

oy · Maturing · Dreams and Spirituality · Being a Woman · Ambition and Challenge • Love and Relations • Creativity • Joy • Maturing • Dreams and Creativity • Joy • Maturing • Dreams and Spirituality • Being a Woman • ambition and Challenge • Love and Relations • Creativity • Joy • Maturing • Relations • Creativity • Joy • Maturing • Dreams and Spirituality • Being a voman • Ambition and Challenge • Love and Relations • Creativity • Joy • · Love and Relations • Creativity • Joy • Maturing • Dreams and Spirituality • oy • Maturing • Dreams and Spirituality • Being a Woman • Ambition and Challenge • Love and Relations • Creativity • Joy • Maturing • Dreams and · Creativity • Joy • Maturing • Dreams and Spirituality • Being a Woman • Ambition and Challenge • Love and Relations • Creativity • Joy • Maturing • and Relations • Creativity • Joy • Maturing • Dreams and Spirituality • Being a Woman • Ambition and Challenge • Love and Relations • Creativity • Joy •

The ine-our youth-it never really goes, does it?

It is all held in our minds.

Helen Hooven Santmyer

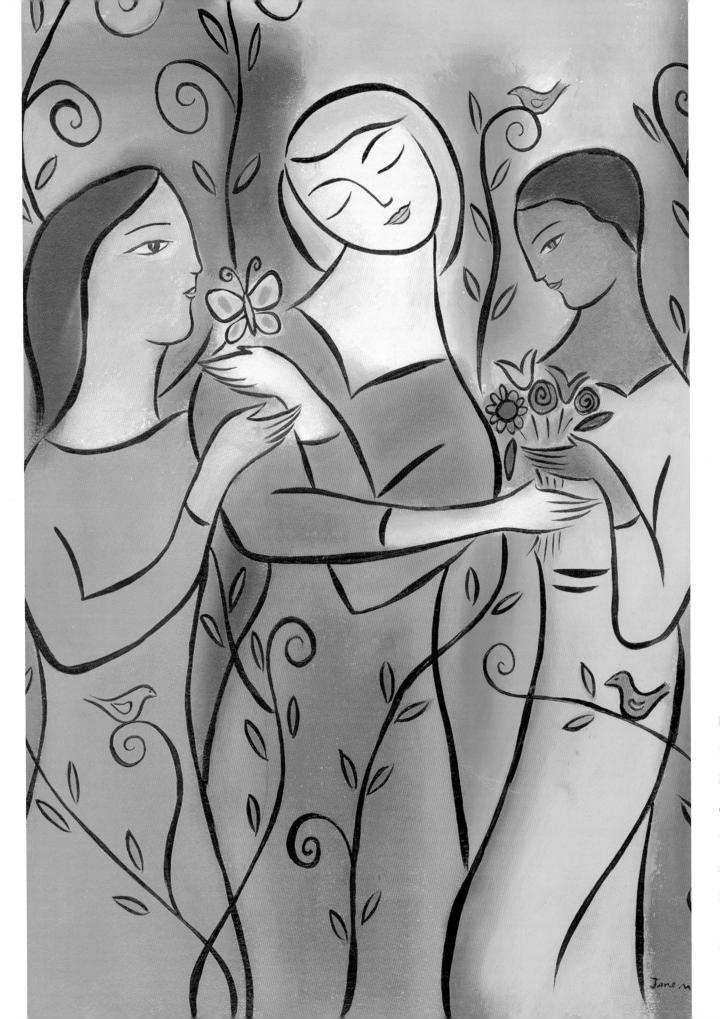

I get into the tub and have long imaginary conversations with whoever's said what's bothering me.

Nancy Reagan

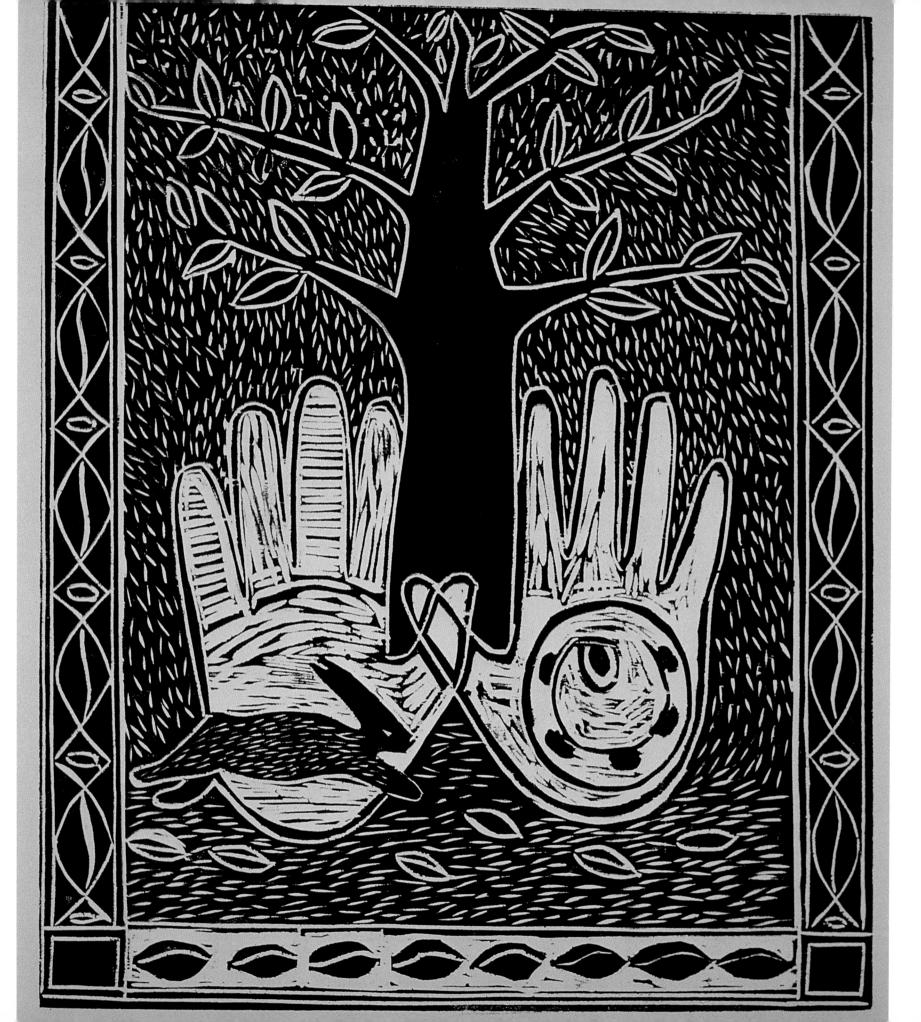

There is a vitality,

a life force,

an energy

that is translated

through you;

and because

there is only One

of you in

all of time,

this expression

is unique.

Martha Graham

The real things haven't changed.

It is still best to be honest and truthful;

to make the most of what we have;

to be happy with simple pleasures;

and have courage when things go wrong.

Laura Ingalls Wilder

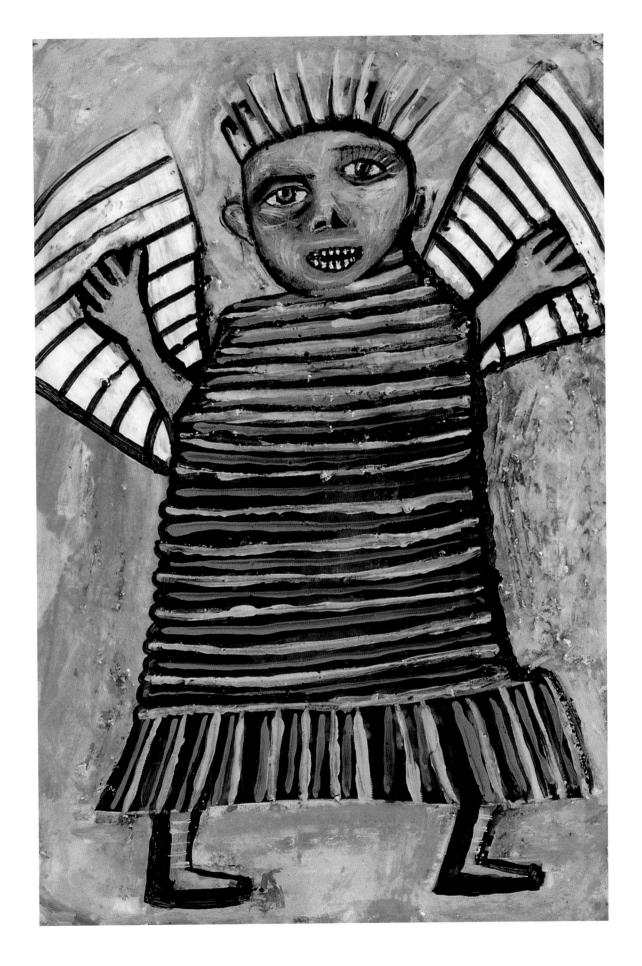

'Twant me,
'twas the Lord.

I always told him,
'I trust to you.

I don't know
where to go
or what to do,
but I expect
you to lead me,'
and He always did.

Harriet Tubman

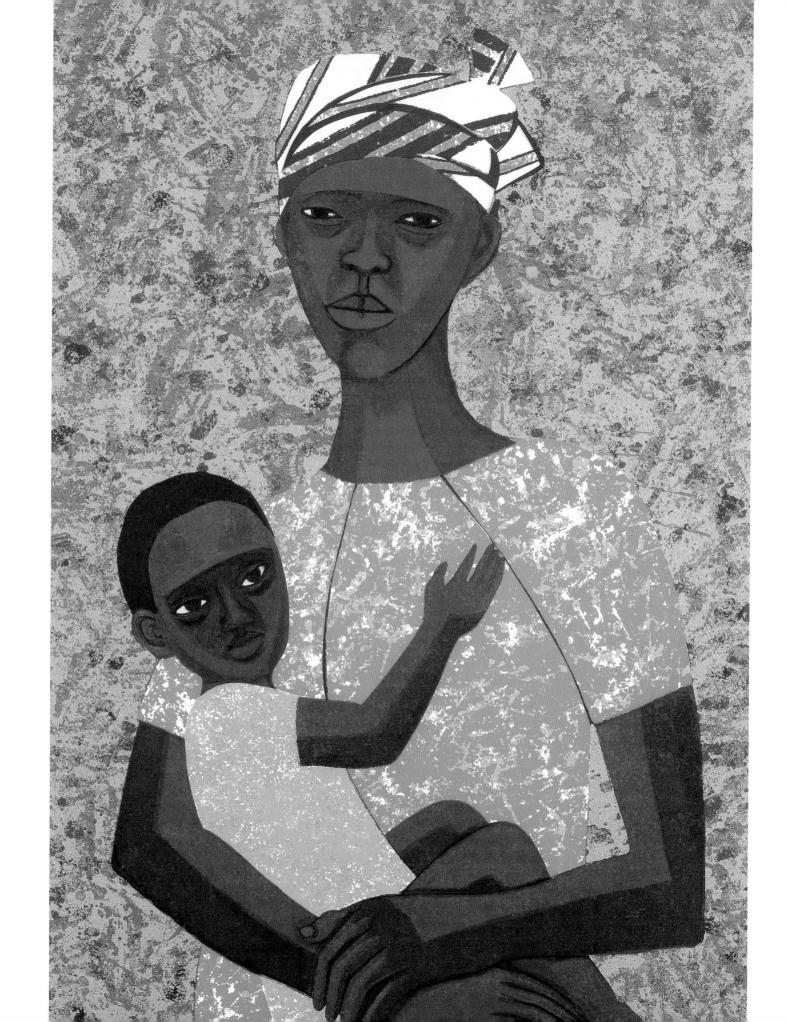

The most beautiful things in the world cannot be seen or even touched.

They must be felt with the heart.

Helen Keller

here is so much in
the world for us all
if we only have the
eyes to see it, and the
heart and the hand
to gather it ourselves...

Lucy Maud Montgomery

hat is happiness; to be dissolved

into something

complete and great.

Willa Cather

If you obey the rules you miss all the fun.

Katherine Hepburn

...your being is full of remembered song!

Bernice Lesbia Kenyon

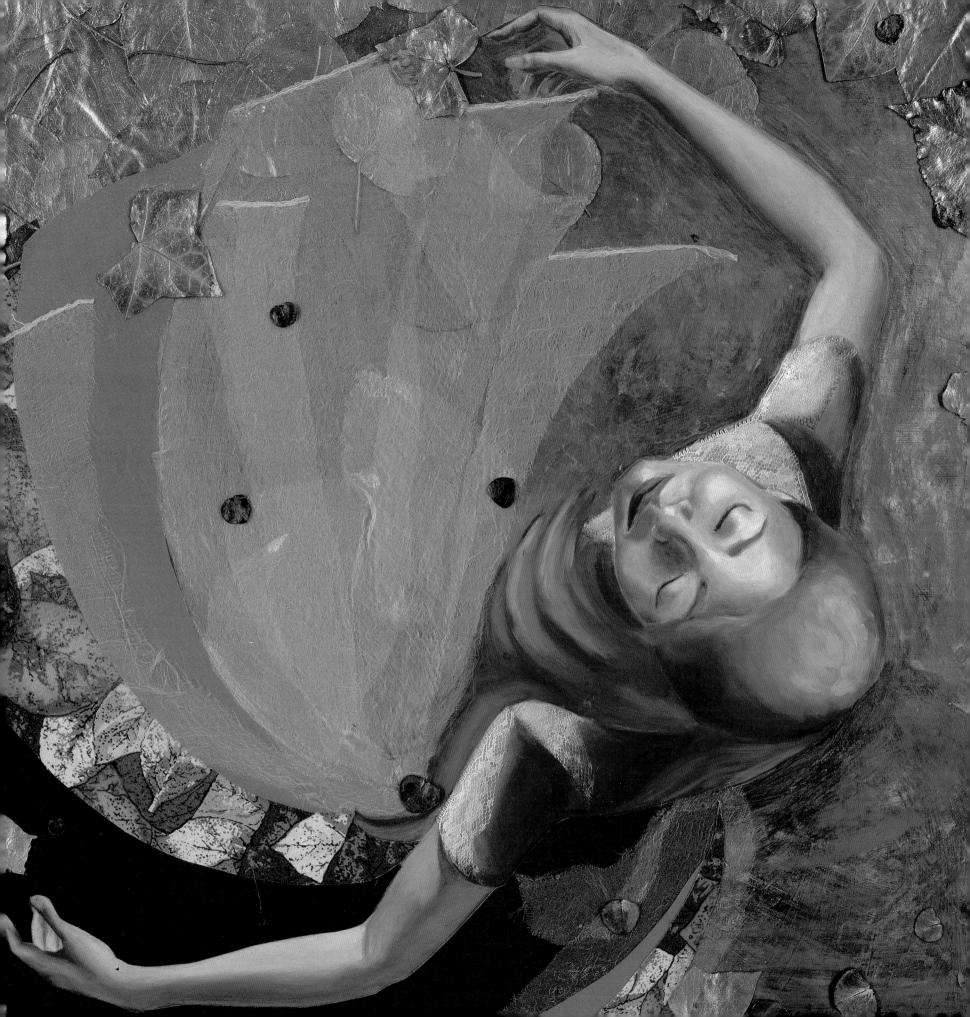

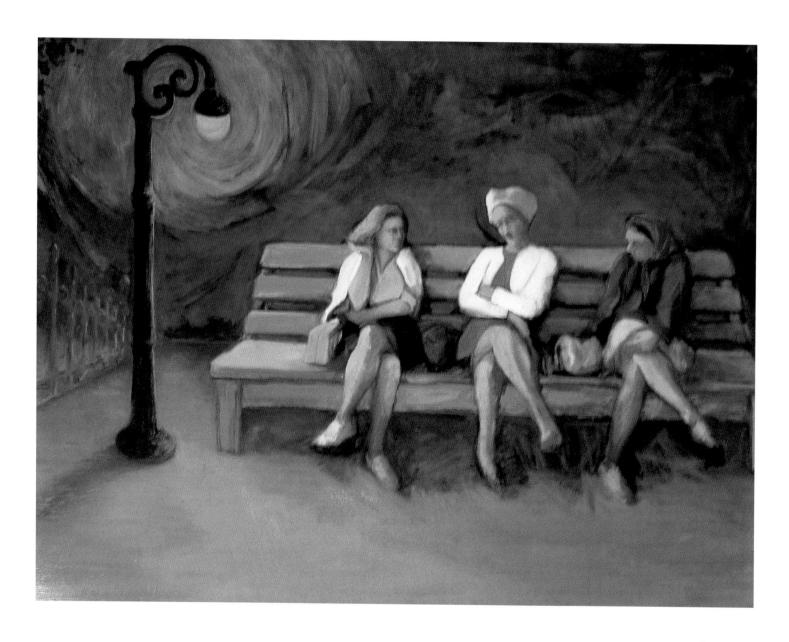

The more you try to be interested in other people, the more you find out about yourself.

Be happy. It's one way of being wise.

Colette

Thoever is happy will make others happy too.

Anne Frank

ou have to count on living every single day in a way you believe will make you feel good about your life — so that if it were over tomorrow, you'd be content with yourself.

Jane Seymour

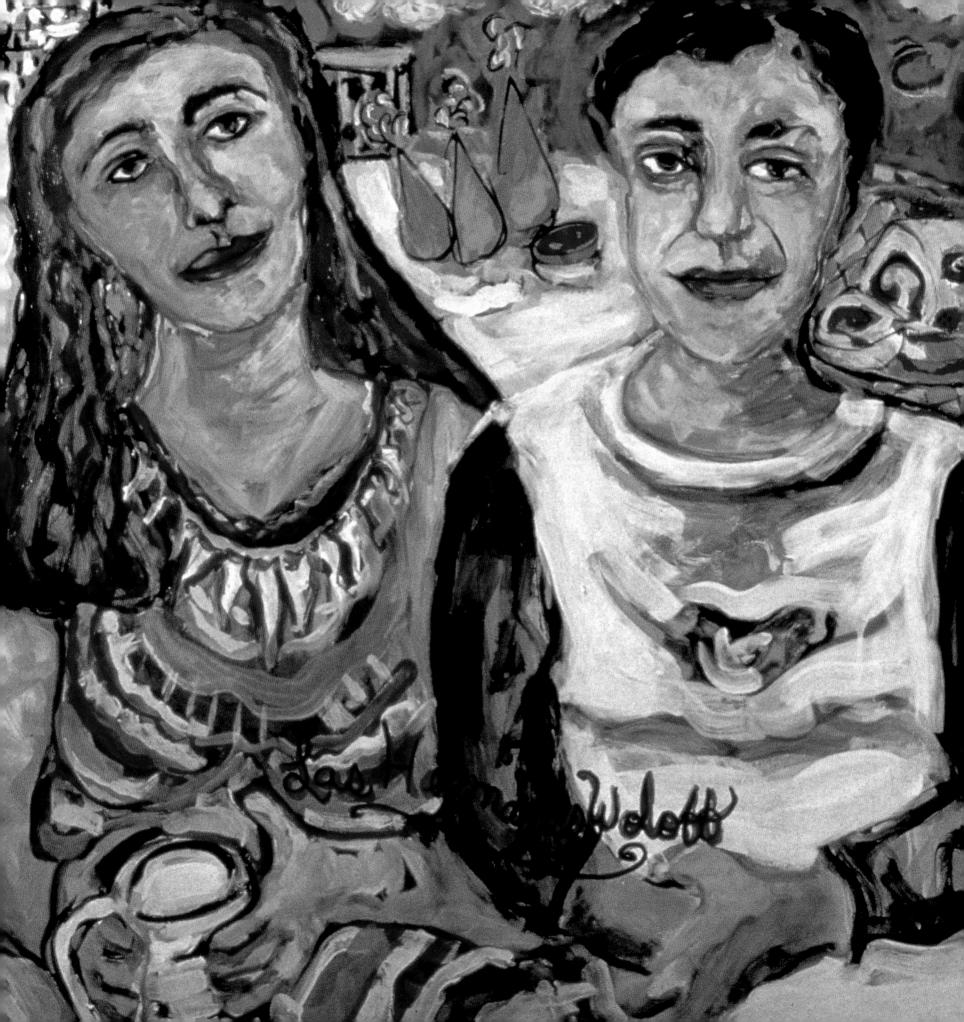

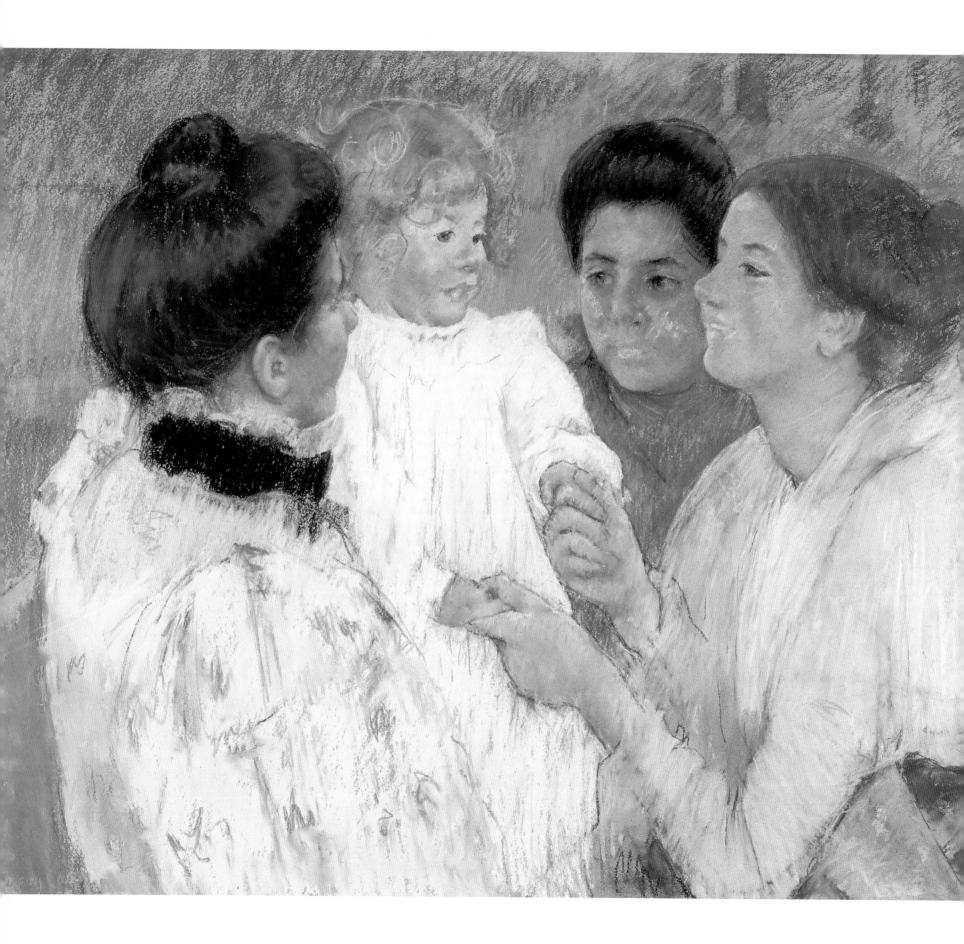

JOY seems

to me a step

beyond

happiness—

happiness is

a sort of

atmosphere

you can live

in sometimes

when you're

lucky. Joy is

a light that fills

you with hope

and faith and love.

Adela Rogers St. Johns

Taking joy in
life is a
woman's best cosmetic.

Rosalind Russell

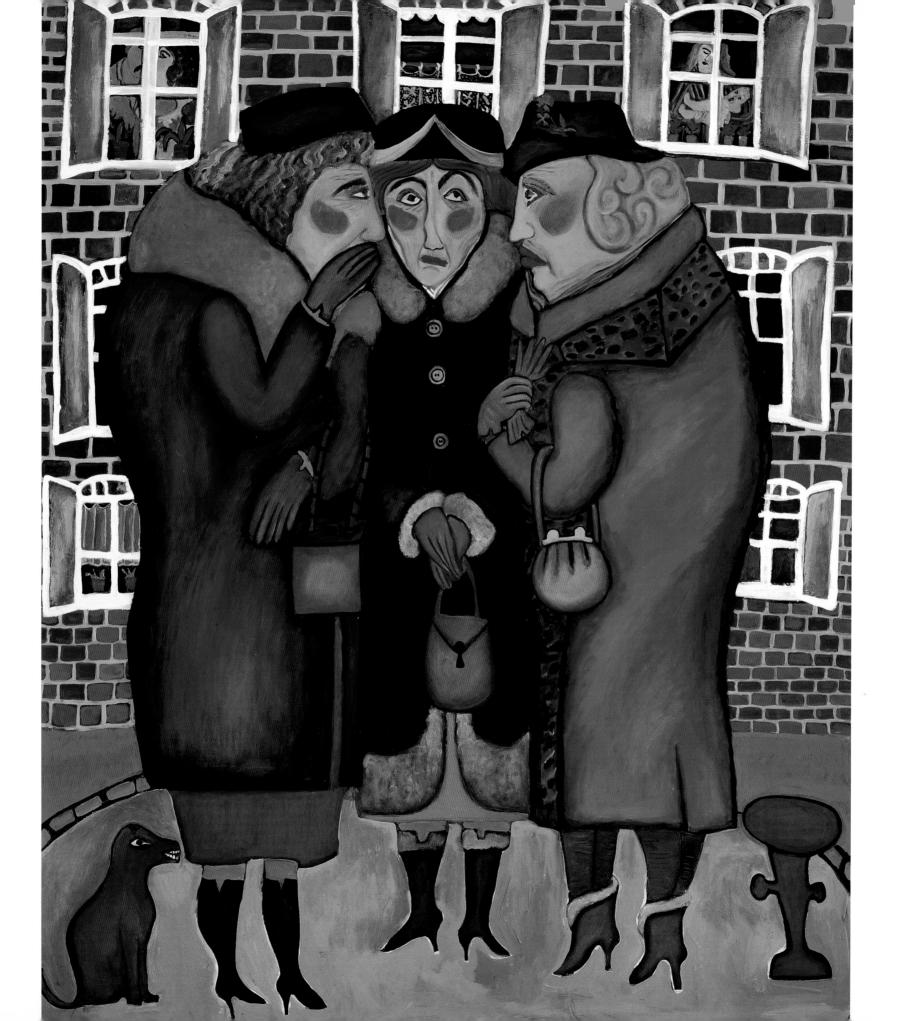

Being a Woman • Ambition and Challenge • Love and Relations • Creativity • oy . Maturing . Dreams and Spirituality . Being a Woman . Ambition and challenge • Love and Relations • Creativity • Joy • Maturing • Dreams and Creativity • Joy • Maturing • Dreams and Spirituality • Being a Woman • ambition and Challenge • Love and Relations • Creativity • Joy • Maturing •: Relations • Creativity • Joy • Maturing • Dreams and Spirituality • Being a Woman • Ambition and Challenge Love and India onsi- Gean ity only • Maturing • Dreams and Sarinal (v • keing a Voyan), Ambition and Collenge Love and Relations • Creativity • Joy • Maturing • Dreams and Spirituality • loy · Maturing · Dreams and Spirituality · Being a Woman · Ambition and Challenge • Love and Relations • Creativity • Joy • Maturing • Dreams and Creativity • Joy • Maturing • Dreams and Spirituality • Being a Woman • Ambinion and Challenge . Love and Relations . Creativity . Joy . Maturing . and Relations • Creativity • Joy • Maturing • Dreams and Spirituality • Being a Woman • Ambition and Challenge • Love and Relations • Creativity • Joy • The hardest years in life are those between ten and seventy.

Helen Hayes _____

...we get to a certain age, and then the rest of our lives we do everything we can to get back to the way we were when we were little...using wisdom to come back to innocence.

Kate Bush

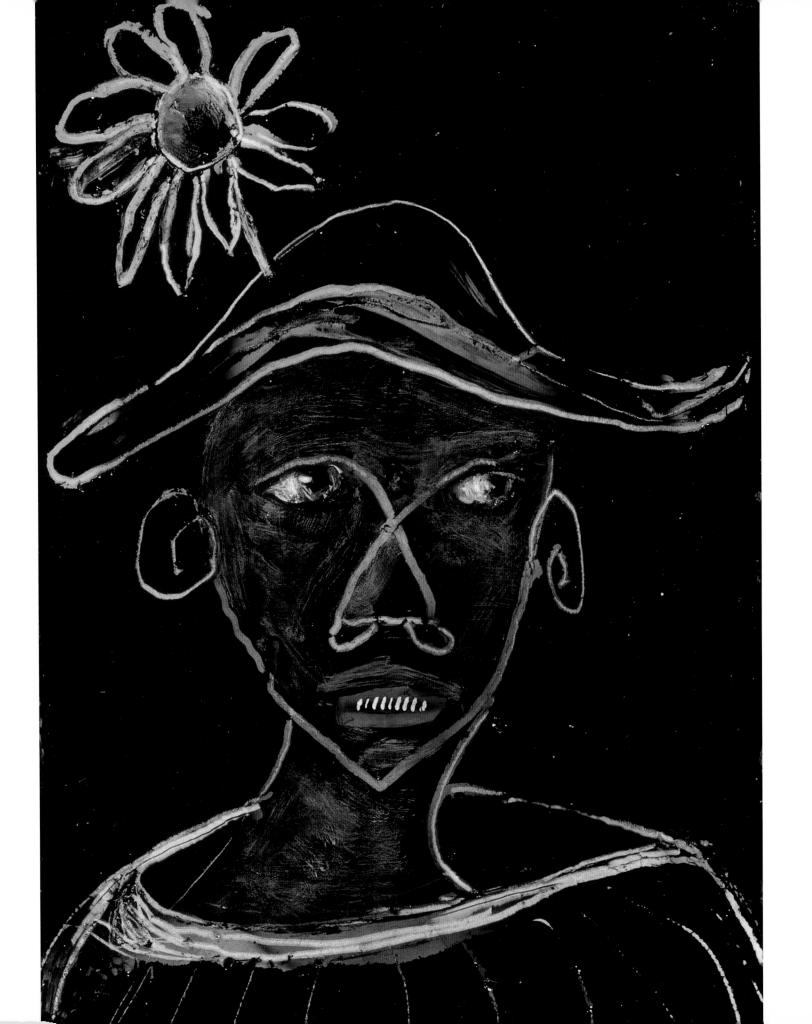

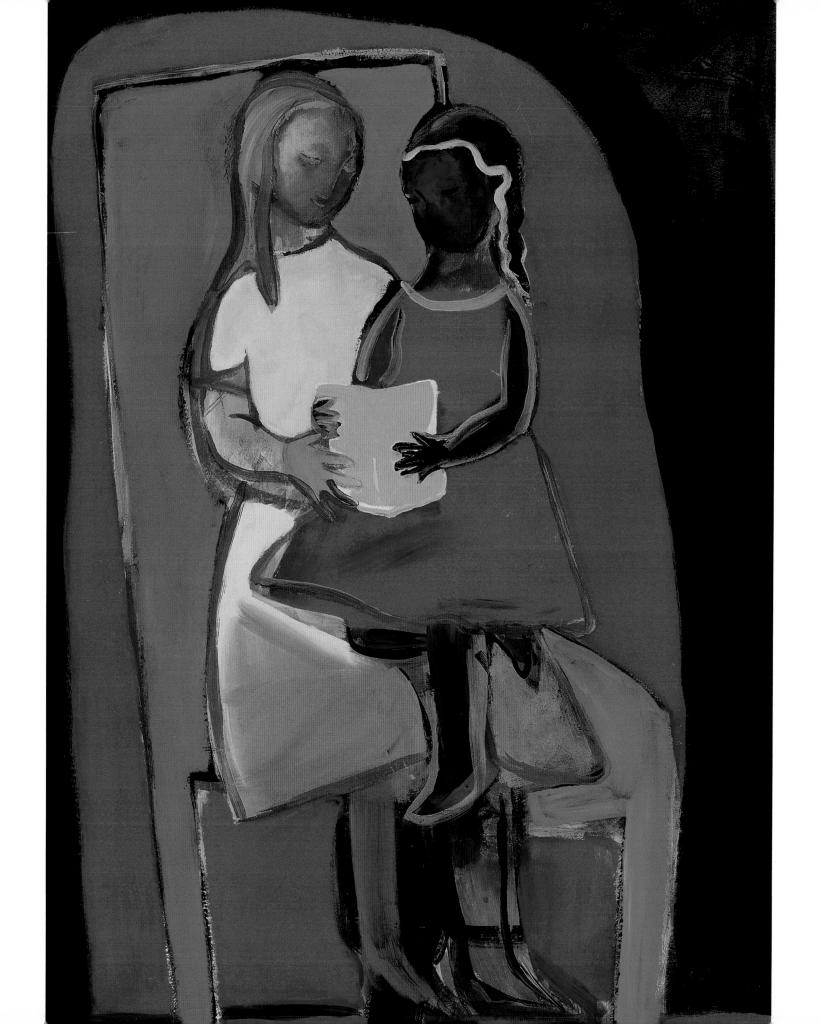

I'm not interested in age.

People who tell

their age are silly. You're as old as you feel.

Elizabeth Arden

speak the truth,
not so much as I would,
but as much as I dare;
and I dare a little more,
as I grow older.

Catherine Drinker Bowen

It's sad to grow old, but nice to ripen.

Brigitte Bardot

Please don't retouch my wrinkles. It took me so long to earn them.

Anna Magnani

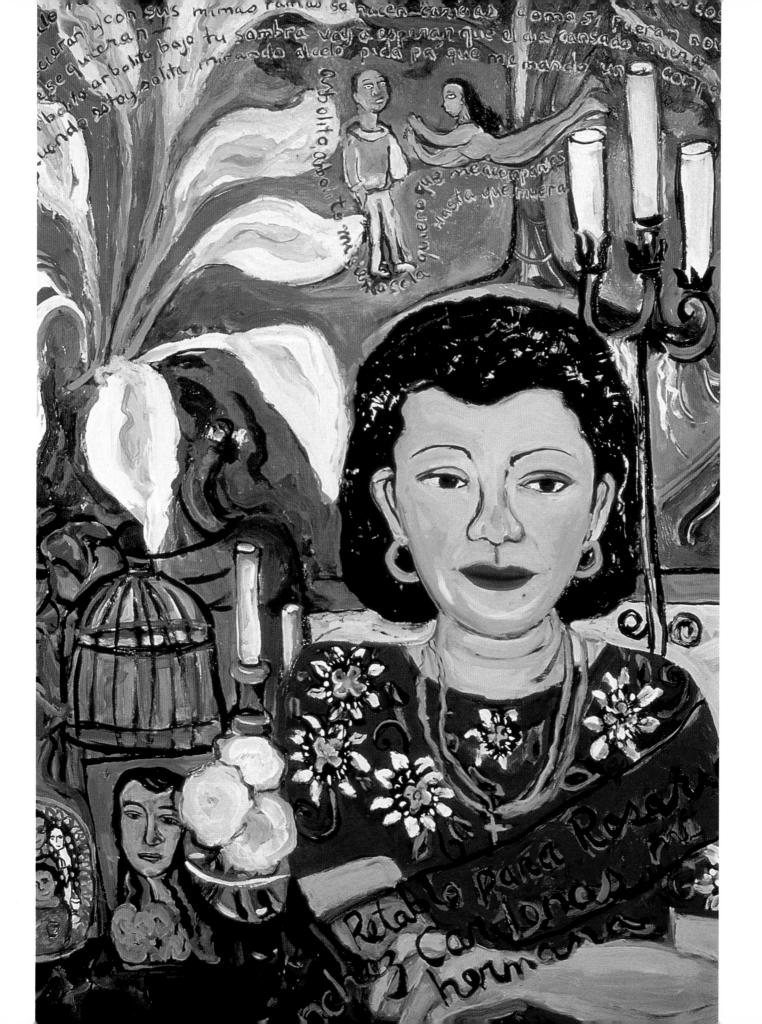

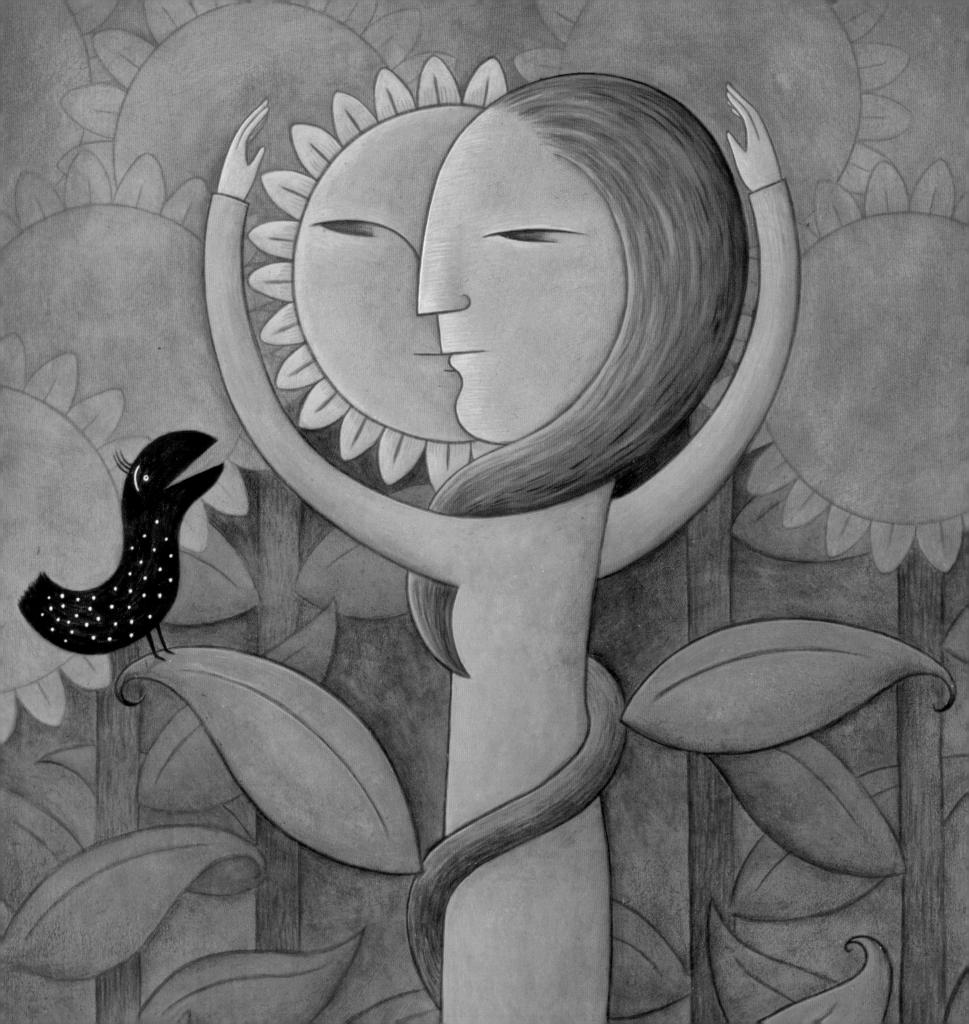

You grow up

the day

you have the

first real

laugh—

at yourself.

Ethel Barrymore

You're
never
too old
to become
younger.

Mae West

here is a fountain of youth:

it is your mind, your talents,

the creativity you bring to your life

and the lives of people you love.

When you learn to tap this source,

You will have truly defeated age.

Sophia Loren

Full maturity...is achieved

by realizing that

you have choices

to make.

Angela Barron McBride

Te grow neither better nor worse as we get old, but more like ourselves.

May Lamberton Becker

One of the many things nobody ever tells you about middle age is that it's such a nice change from being young.

Dorothy Canfield Fisher

After a certain number of years,

our faces become our biographies.

Cynthia Ozick

The secret to staying
younger is to live honestly,
eat slowly, and just
not think about your age.

Lucille Ball

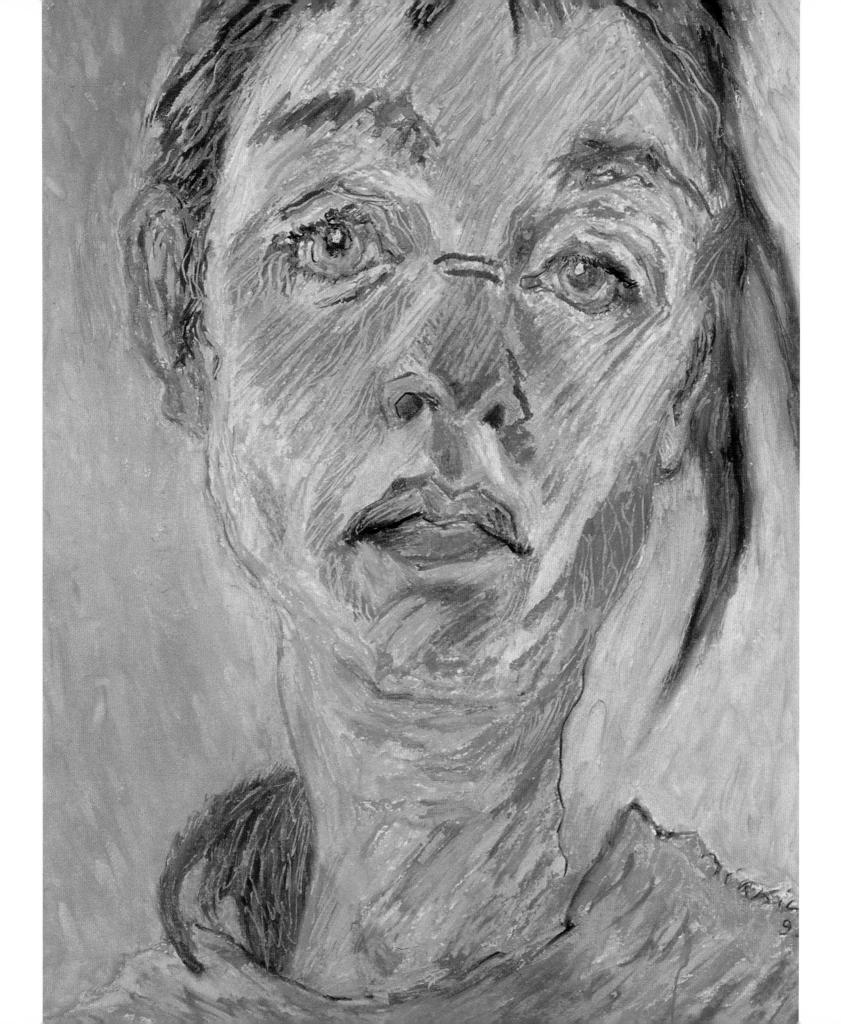

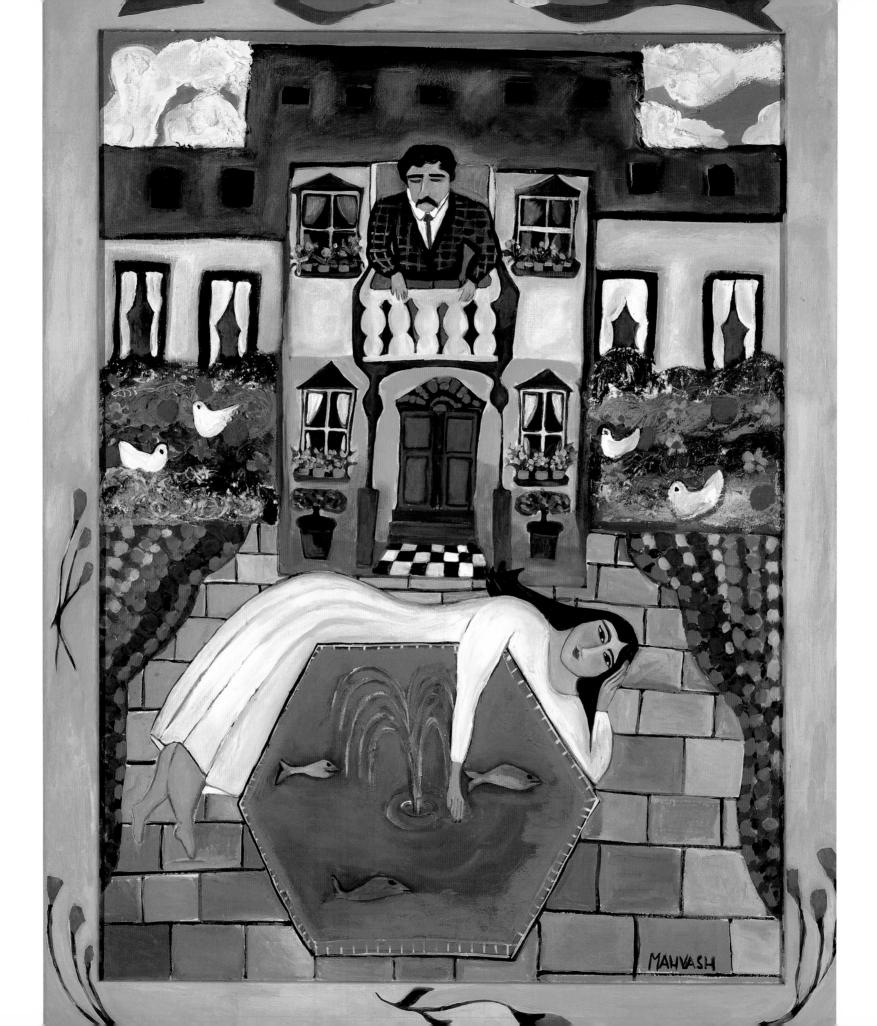

eing a Woman • Ambition and Challenge • Love and Relations • Creativity • oy · Maturing · Dreams and Spirituality · Being a Woman · Ambition and Challenge • Love and Relations • Creativity • Joy • Maturing • Dreams and pirituality · Being a Woman · Ambition and Challenge · Love and Relations Creativity • Joy • Maturing • Dreams and Spirituality • Being a Woman • Dreams and Spirituality •Being a Woman • Ambition and Challenge • Love and Relations • Creativity • Joy • Maturing • Dreams and Spirituality • Being at daturing • Dreams and Spirituality • Being a Woman • Ambition and Challenge and Refugnise Greaters of the uring Dreams and Spirituality of a Woman of Alabition and thallenge of Love and Relations of Creativity of · Maturing · Dreams and Spirituality · Being a Woman · Ambition and Challenge • Love and Pelations • Creativity • Joy • Maturing • Dreams and Spirituality • Being a Woman • Ambition and Challenge • Love and Relations realivity • Joy • Maturing • Dreams and Spirituality • Being a Woman • Ambiron and Challenge • Love and Relations • Creativity • Joy • Maturing • Dreams and Spirituality • Being alwoman + Ambilon and Challenge • Love Creativity
 Joy
 Maturing
 Dreams and Spiritualing a Woman • Ambition and Challenge • Love and Relations • Creativity • Joy •

Dreams have only one owner at a time.

That's why dreamers are lonely.

Erma Bombeck

If you have made mistakes...there is always another chance for you...you may have a fresh start any moment you choose, for this thing we call 'failure' is not the falling down, but the staying down.

Mary Pickford

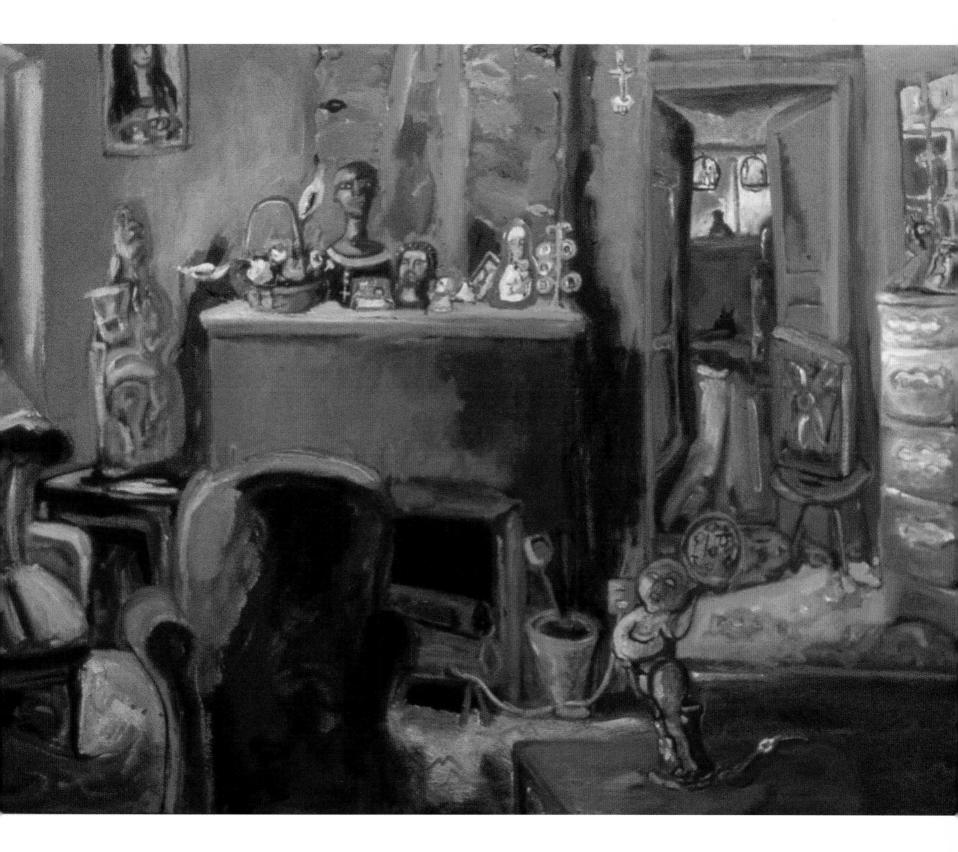

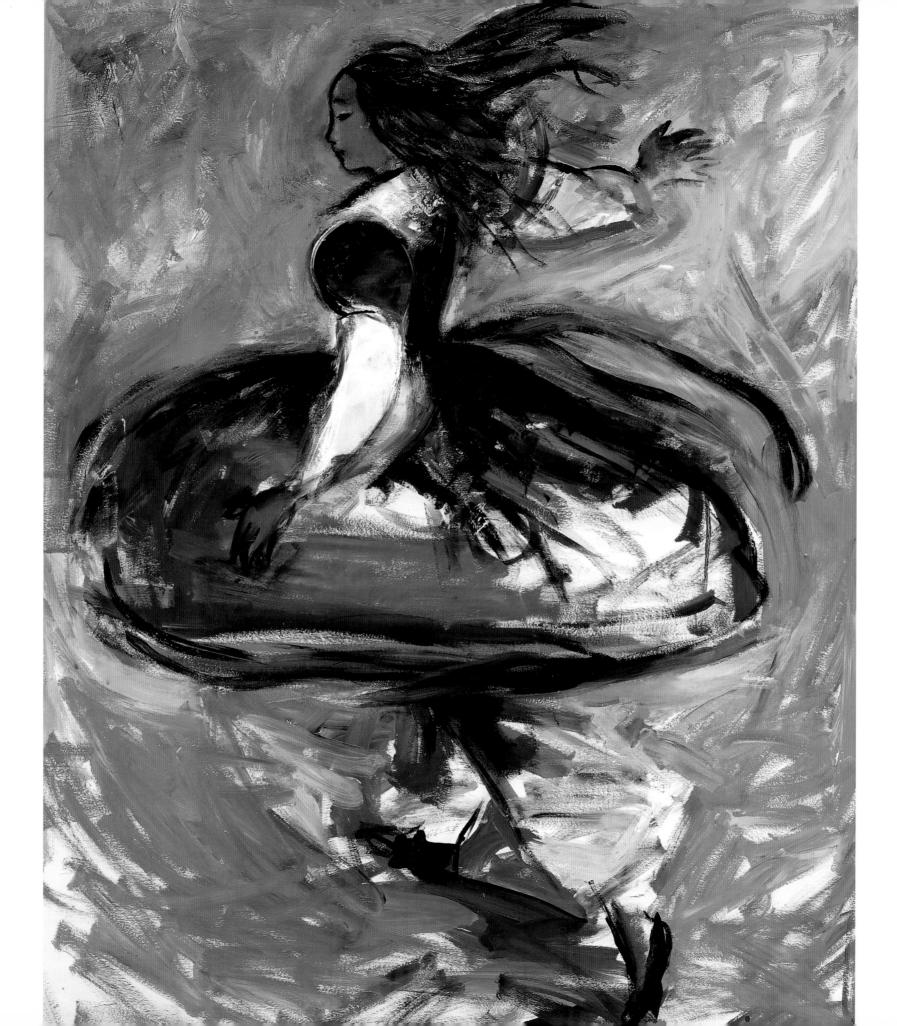

I've dreamt in my life dreams that have stayed with me ever after, and changed my ideas; they've gone through and through me, like wine through water, and altered the color of my mind.

Emily Brontë

The dream was always running ahead of one.

To catch up, to live for a moment in unison with it, that was the miracle.

Anaïs Nin

It isn't until

you come to

a spiritual

understanding

of who you are—

not necessarily

a religious feeling,

but deep down,

the spirit within—

that you can begin

to take control.

Oprah Winfrey

ITe need time to dream,

time to remember,

and time to reach the infinite.

Time to be.

Gladys Taber

he first 'dream of success' is a part of our youth. To start over after failing the initial dream is a part of our maturing process.

Kathleen de Azevedo

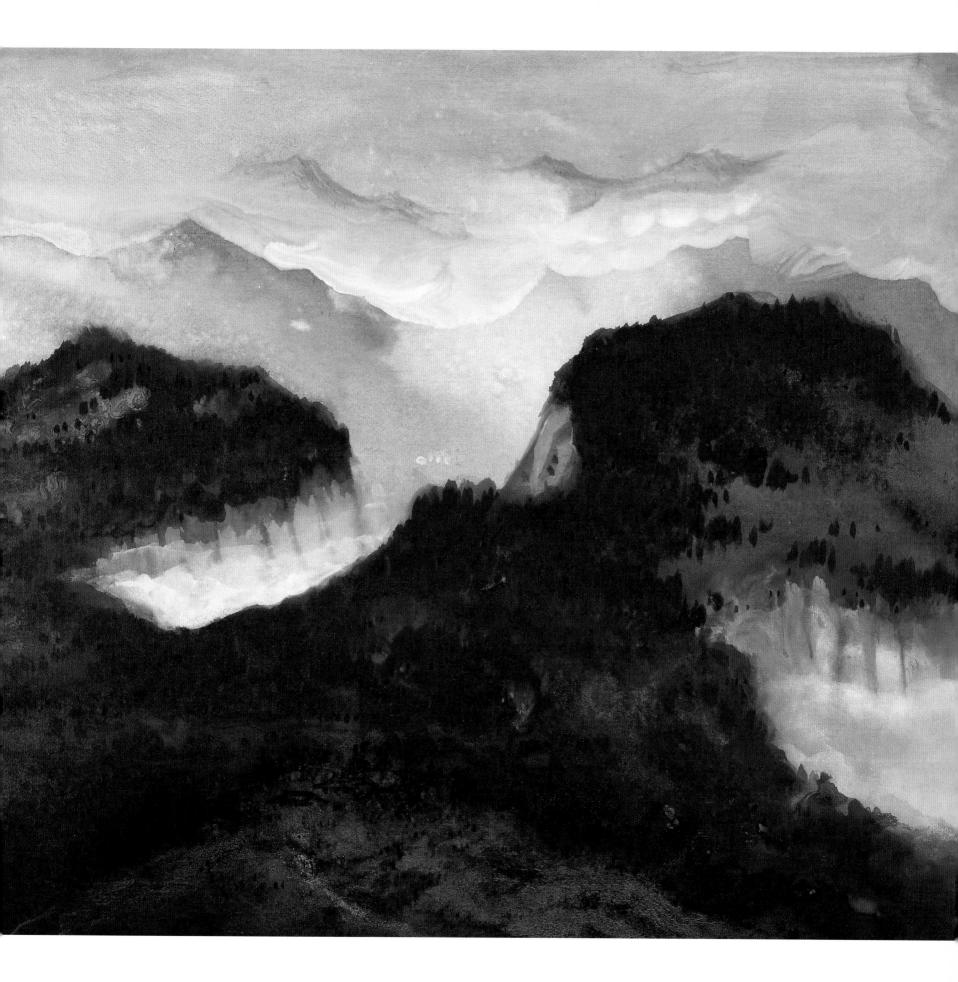

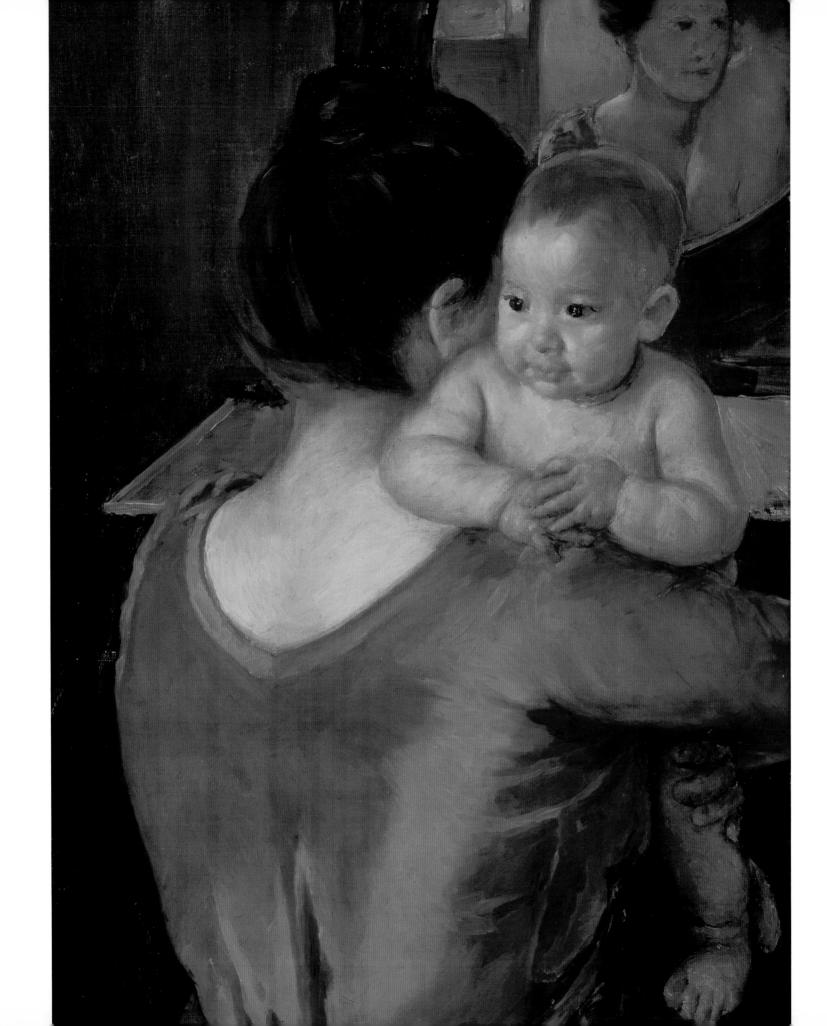

...the soul and the spirit have resources that are astonishing.

Like wolves and other creatures, the soul and spirit are able to thrive on very little, and sometimes for a long time on nothing.

To me, it is the miracle of miracles that this is so.

Clarissa Pinkola Estes

The future belongs to those who believe in the beauty of their dreams.

Eleanor Roosevelt

I was not

looking

for my dreams

to interpret

my life,

but rather for

my life to

interpret

my dreams.

Susan Sontag

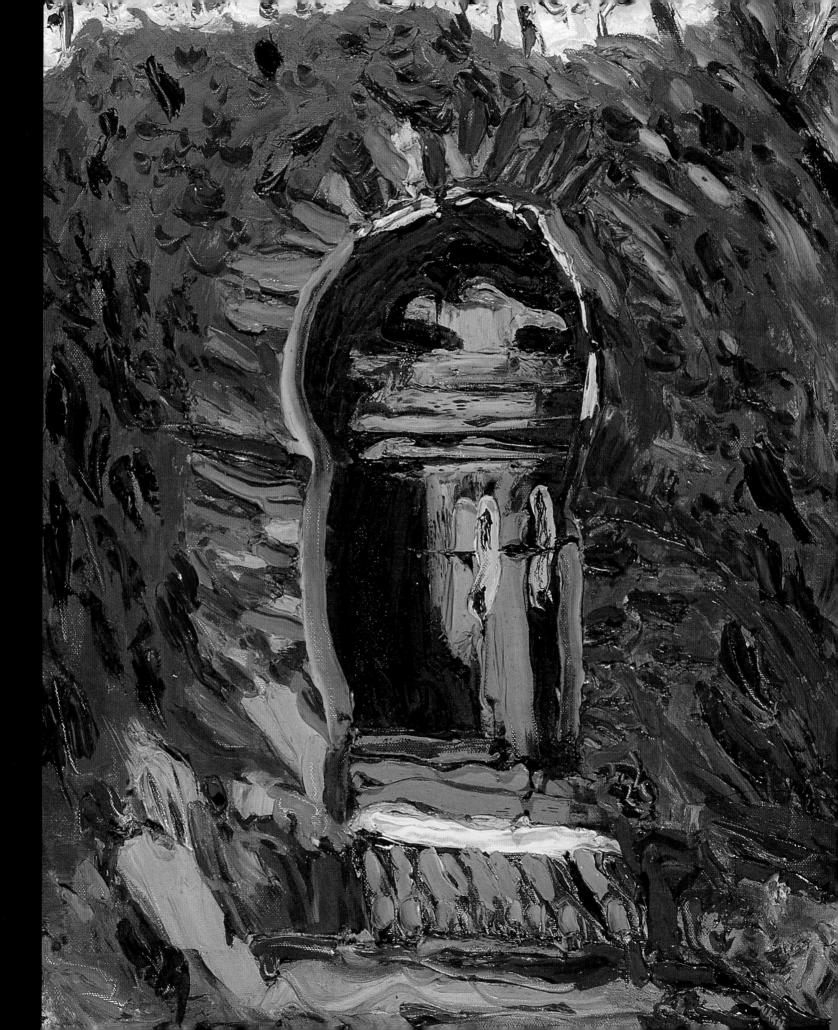

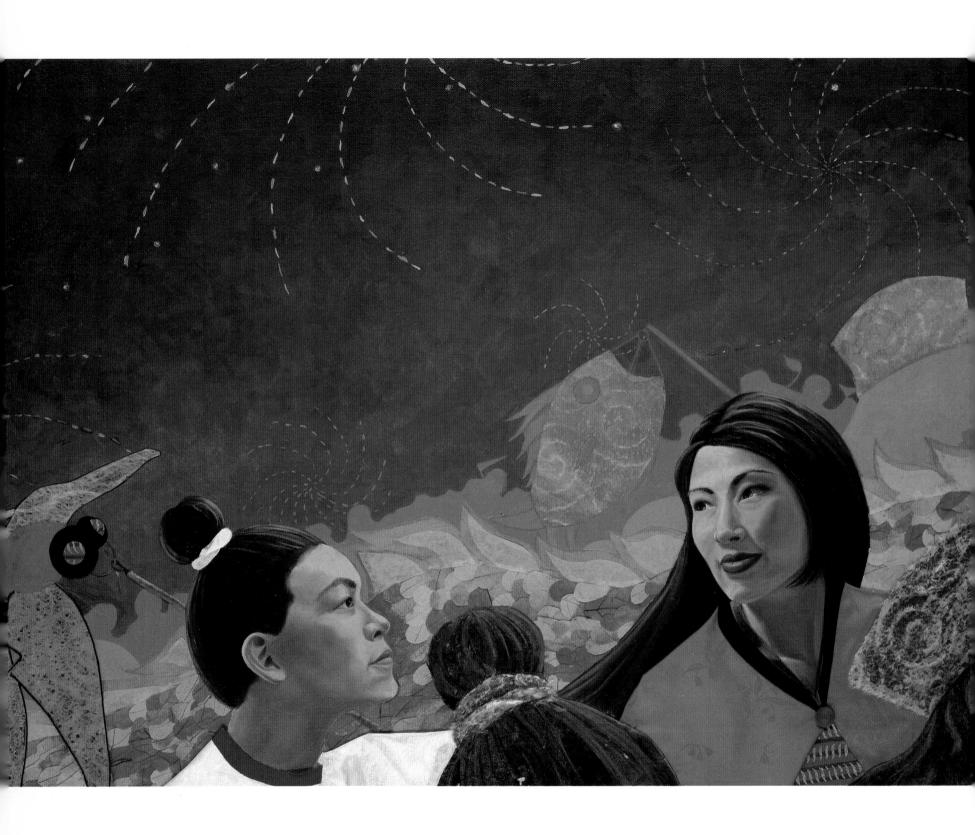

Reach high,

for stars lie hidden in your soul.

Dream deep,

for every dream precedes the goal.

Pamela Vaull Starr

...immortality is the passing of a soul through many lives or experiences, and such are truly lived, used, and learned, help on to the next, each growing richer, happier and higher, carrying with it only the real memories of what has gone before...

Louisa May Alcott

It seems to me we can never give up longing and wishing while we are alive.

There are certain things we feel to be beautiful and good, and we must hunger for them.

George Eliot

believe that dreams transport us through the underside of our days, and that if we wish to become acquainted with the dark side of what we are, the signposts are there, waiting for us to translate them.

Gail Godwin

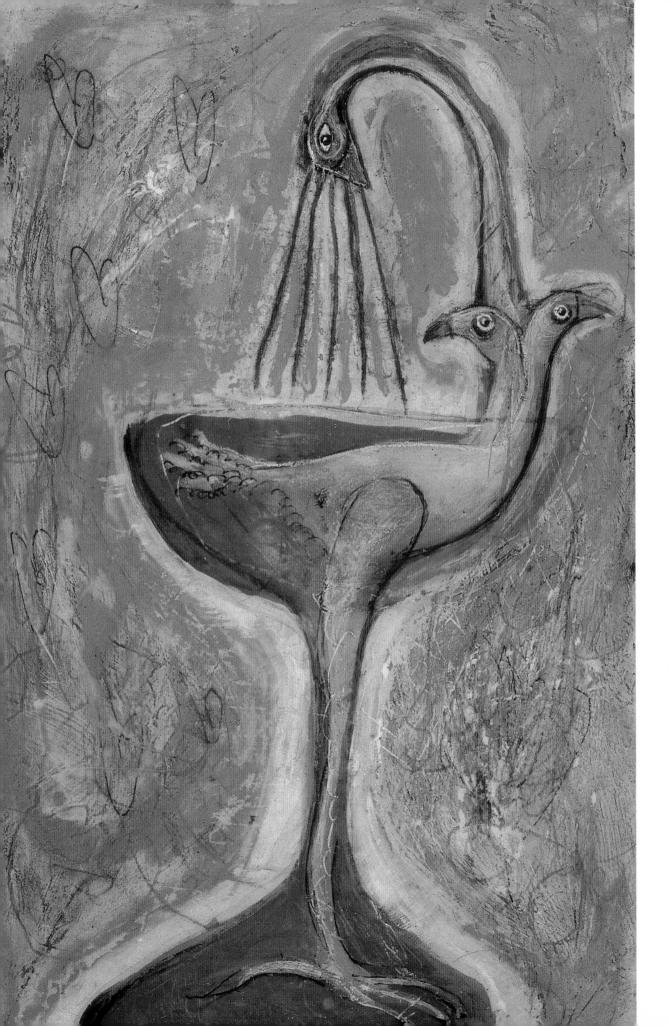

...Dreams

are, by definition,

cursed with

short life spans.

Candice Bergen

- Front cover: Detail from *Sweet Life* (1985), by Mahvash Courtesy of the artist.
- Back cover and p. 19: Farm at Watendlath (1921), by Dora Carrington. Tate Gallery, London; Art Resource, NY.
- p. 6: Self Portrait with Hat (1991) © Michelle Clement/Licensed by VAGA, New York, NY.
- p. 8: Living in a Miniature Doll House (1997), by Mahvash Mossaed. Courtesy of the artist.
- p. 11: Blue Dancer (1996), by Jane Mjolsness. Courtesy of the
- p. 12: Moon Maiden (2000), by Roxana Villa. Courtesy of roxanavilla.com
- p. 15: Mama's Helper (1998), by Kelly Stribling Sutherland. Courtesy of the artist.
- p. 16: Don't Touch (1996), by Rachel Bliss. Courtesy of the artist.
- p. 20: Yolander (1998), by Jane Mjolsness. Courtesy of the
- p. 23: Sleeping in the Birdland (1990), by Mahvash Mossaed. Courtesy of the artist.
- p. 24: *Time Pieces* (1998), by Kelly Stribling Sutherland. Courtesy of the artist.
- p. 27: Rowhouse #21: Wildflowers. Detail from 9 Rowhouses (1998), by Amy Orr. Courtesy of the artist.
- p. 28: Spring (1997), by Rachel Bliss. Private Collection.
- p. 31: Girl with Peacock Feather (19TH century), by Marie Sparteli Stillman., The Maas Gallery, London, UK/Bridgeman Art Library, London.
- p. 32: Sharecropper (1968), © Elizabeth Catlett/Licensed by VAGA, New York, NY.
- p. 35: Wet Los Angeles Night (1991) © Michelle Clement/Licensed by VAGA, New York, NY.
- p. 36: Empty Stairwell (1997) by Kellyann Monaghan. Courtesy of the artist.
- p. 39: Illustrations designed by Jacqueline Mair and Roger la Borde©, London.
- p. 40: Butterfly and Flower (1998), by Christina Hess. Courtesy of the artist.
- p. 42: We built a wall to keep all things not beautiful (1985), by Mahvash Mossaed. Courtesy of the artist.

- p. 45: Toomsuba II (1974), © Valerie Jaudon/Licensed by VAGA, New York, NY.
- p. 46: Hope (1997) by Carol S. Nowak. Courtesy of the
- p. 49: Flora (1894), by Evelyn de Morgan, The De Morgan Foundation, London, UK/Bridgeman Art Library.
- p. 50: At the River's Edge (1998) by Emily Brown. Private Collection.
- p. 53: Life could not be beautiful all the time (1998), by Mahvash Mossaed. Courtesy of the artist.
- p. 54: Lover's Embrace (1989), © Grimanesa Amoros/Licensed by VAGA, New York, NY.
- p. 57: Glimpses in a window series (1996), by Patricia M. Siembora. Courtesy of the artist.
- p. 58: Marge's Lupine's (1992) by Emily Brown. Private Collection.
- p. 60: Dragon (1992) © Idaherma Williams/Licensed by VAGA, New York, NY.
- p. 63: Flower Girls (1999), by Kelly Stribling Sutherland. Courtesy of the artist.
- p. 64: Autumn (1999), by Roxana Villa. Courtesy of roxanavilla.com
- p. 67: Self Portrait (1997), by Rachel Bliss. Private Collection.
- p. 68: Lustre of Autumn (1995), © Diana Kan/Licensed by VAGA, New York, NY.
- p. 71: Illustrations designed by Jacqueline Mair and Roger la Borde©. London.
- p. 72: Woman and Child in a Garden (c. 1883–4), by Berthe Morisot, National Gallery of Scotland, Edinburgh, Scotland/ Bridgeman Art Library.
- p. 75: August Sky (1999), by Amy Orr. Courtesy of the artist.
- p. 76: C.G. Garage II (2000) by Kellyann Monaghan. Courtesy of the artist.
- p. 78; Miss Lou 3 (1996), by Rachel Bliss. Private Collection.
- p. 81: $\mathit{Three\ Women}\ (1999)$, by Jane Mjolsness. Courtesy of the artist.
- p. 82: Tree of Life (1995) by Carol S. Nowak. Courtesy of the artist.
- p. 85: Angel (1997), by Rachel Bliss. Courtesy of FAN Gallery, Philadelphia, PA.

- p. 86: Madonna II (1991), © Elizabeth Catlett/Licensed by VAGA, New York, NY.
- p. 89: Yvette (1998), by Christina Hess. Courtesy of the artist.
- p. 90: Three Women (1984), by Rosalind Bloom. Courtesy of the artist.
- p. 93: Las Hermanas Woloff (1997), by Marta Sánchez. Courtesy of the artist.
- p. 94: Women Admiring a Child (1897), by Mary Cassatt, The Detroit Institute of the Arts, USA/ Bridgeman Art Library.
- p. 96: *The Gossipers* (1995), by Mahvash Mossaed. Courtesy of the artist.
- p. 99: Shulane (1999), by Rachel Bliss. Courtesy of Riverbank Arts, Stockton, N.J.
- p. 100: *Quiet Time* (2000), by Kelly Stribling Sutherland. Courtesy of the artist.
- p. 103: Retablo Para Mi Hermana Rosario Sánchez Cardenas (1994), by Marta Sánchez. Courtesy of the artist.
- p. 104: Sunflower (1992), by Roxana Villa. Courtesy of roxanavilla.com
- p. 107: Illustrations designed by Jacqueline Mair and Roger la Borde©, London.
- p. 108: Daylily (1996), by Marta Sánchez. Courtesy of the artist.
- p. 111: *Rabbi, I want to see. Mark 10:51* (1999), by Helen Mirkil. Courtesy of the artist.
- p. 112: Until he came to the balcony to call me up (1997), by Mahvash Mossaed. Courtesy of the artist.
- p. 115: La Casa de Sra. Muñiz (1984), by Marta Sánchez. Courtesy of the artist.
- p. 116: Clara (1987), by Kelly Stribling Sutherland. Courtesy of the artist.
- p. 119: After the Rain (1994), © Diana Kan/Licensed by VAGA, New York, NY.
- p. 120: Mother and Child (1900), by Mary Cassatt, Brooklyn Museum of Art, New York, USA/Bridgeman Art Library.
- p. 123: Garden Door (1999), by Helen Mirkil. Courtesy of the artist.
- p. 124: Parade (2000), by Christina Hess. Courtesy of the artist.
- p. 125: Untitled (1997), by Rachel Bliss. Courtesy of the artist.